Nicolas
Bourriaud

Inclusions

D1300760

Aesthetics
of the
Capitalocene

Sternberg Press

Introduction

CHAPTER 1

The Work of Art in the Age of Global Warming

CHAPTER 2

Towards Inclusive Aesthetics

CHAPTER 3

The Artist as Molecular Anthropologist

Coda

Introduction

Every isolable element of the universe always appears as a particle that can enter into composition with a whole that transcends it.

Georges Bataille

What the Western world calls nature produces neither waste nor works of art. Even though we can't reconcile or dissociate them, they form the poles of the human world. While waste is unwanted and not considered private property, art has an undeniable social value. We find the same polarity in the industrial world: industrial overproduction generates an escalating layer of trash, while what we consider as culture springs from excess energy. But the time lag between commodity and refuse keeps getting shorter, reducing the usage time of things and the life span of representations. Throwing away a plastic object or swiping away a picture glimpsed on-screen are two gestures that belong to a general symbolic system, a vision of the world where the human being is no longer a full participant of life on earth, but a material caught up in a mechanism. The climate crisis, caused by the geological epoch defined as the Anthropocene, coincides with a global cultural crisis. What does art mean in a world driven by urgency, a world that exhausts its annual renewable resources midway through the year?

Just like patented natural resources—the roots, seeds, and minerals that "belong" to companies that commercialize them—images and artworks are restricted by copyright law. The most devastating power of our era, even more formidable than typhoons or the rise in water levels, is that of private property, which has invaded our brains. This general trend toward the privatization of the world makes our era comparable to the Neolithic Age, which saw the emergence of agriculture and animal husbandry, and now a new phase in the industrialization of the living is being implemented. Agriculture was the process by which human beings changed the ecosystem in order to control the biological cycle of domesticated species to produce useful resources. In Europe, a new step was taken in the late fifteenth century: the "primitive accumulation" of capital started with the confiscation of common lands cultivated by peasants by private owners, who then became employers. Known as *enclosure*, the purpose of this policy was to constitute an abstract workforce and produce mechanized, delocalized bodies. Today, our digital Neolithic Age has amplified this domestication by extending it to new entities, namely, human data and all living things. The internet is the primary instrument of this novel phase of domestication because it allows the large-scale mental confinement

of human populations: as over-sedentarization takes hold, humans join the list of material "resources" to be exploited (plants, animals, forests, the earth's crust, etc.). And the global lockdown caused by the COVID-19 pandemic has given us a glimpse of the next level of confinement. Since we have all interiorized the idea that our role on Earth consists in being of immediate use to the production system, the only thing left to exploit is our remaining leisure time and private lives. We know that with the invention of the wheel and the emergence of agrarian culture, the human population took a decisive turn that led, among other things, to the constitution of the first city-states. So it is unsurprising that contemporary modes of governance are disrupted by the general domestication process of the living that turns both humans and nonhumans into raw materials.

Today, companies have succeeded the cities, kingdoms, and nations of the past, which remain only as objective allies of corporate domination. Ironically, borders are what allow capital to elude control and what stand in the way of genuine ecological policies: you can't ask oil waste for its passport or nationalize the atmosphere. Although the term "ecology" refers to the domestic sphere (*oikos*, in Greek), it does not inspire us to see the world as a shared system, a network of pollinations and coactivities. But the world is not a "house" ruled over by a patriarch; it is a space we are meant to share with other life-forms, with the Other, which includes viruses and bats. And though "ecology always considers the environment exclusively in terms of habitat," as Emanuele Coccia writes, it has become crucial "to recognize that there is such a thing as the uninhabitable, that space can never be, and will never be, definitively inhabited," and that we should, rather than control it, blend in with it.[1]

The climate crisis is the first event that has synchronized human societies since Christopher Columbus arrived in America. As the ecological disaster unfolds, Amazonian peoples and G7 leaders share the same situation: for lack of anything better, we can celebrate the disastrous synchronicity that forces us to acknowledge the existence of interactions and connections between cultures,

[1] Emanuele Coccia, *The Life of Plants: A Metaphysics of Mixture* (Cambridge: Polity Press, 2019), 95.

forms of life, and ecosystems that those in the West have been destroying for centuries. Humans and nonhumans, for the first time since the Neolithic Age, have been forced to invent a mode of *cooperation*, and human technology has to turn to what Peter Sloterdijk calls "homeotechnology," that is, technical knowledge operating *from within* natural forces rather than violating them in a relation of domination. Taoist China, the Dogon, the Cherokee, and the Mapuche were already attuned to this mode of thinking, which goes to show that looking backward is not always a bad thing, except that this is not going backward but rather belatedly including voices silenced by the West.

 At the same time, individuals connect to each other and access real-time information online; continuously bombarded by information, their attention is overstretched. Densification is overrunning the planet, and the human population of the twenty-first century will reach unprecedented numbers. If our epoch is indeed one of synchronized temporalities, capitalism and ecological catastrophe are both dragging us toward standardization: homogeneity and abstract universality. The struggles for new "commons" have not dispelled the dominant ideology based on binary and abstract oppositions—far from it. But the rise of homeotechnologies must bring about a new holism, an *inclusive* approach to the world, a thought immersed in the natural milieu that we have been taught to see as an "environment."[2] What Jacques Lacan called the "mirror stage" is the moment when the human child sees him- or herself for the first time as a whole rather than a series of fragments. I am convinced that the Anthropocene is our collective mirror stage. It replaces the vision of a world dismembered and labeled by economic predation with the image of an *integral* universe made of vital connections and interdependences. For artists today, this inclusive approach to the world expresses itself through an updated version of totemism. Which bring us to anthropology: the term designates a mode of social organization based on the totem, that is, the conviction that there is a connection, a common essence

[2] Translator's note: In the original French, the author establishes a clear distinction between *milieu* and *environnement*. As both translate into English as "environment," we have decided to maintain the word milieu, to be understood here in the broader sense given by the anthropologist Jeremy Narby.

between a person or a group and natural species (animal, vegetal, or even atmospheric). The central idea of totemism is the existence of a connection, of a dynamic co-naturality, between human beings and their milieu.

The Anthropocene also teaches us another lesson: opposing globalized capitalism goes hand in hand with opposing colonial thought and patriarchy, since they are the three facets of the same ideological object, three variations of a system of thought whose source can be found in the division between nature and culture established by the West. From the sixteenth century onward, when the division between the body, seen as vile and purely animal, and the mind, divinely delegated to control it, was decreed by the West, it became easy to condemn the "state of nature" wherever it existed. Capitalist rationalization of labor is inseparable from this radical break between human beings and their milieu, itself inseparable from a partition of nature into abstract and marketable units. But it also goes together with a fact that is less commented on: indeed, for villagers, before becoming the place where they were paid to work, common fields were also a space for life and subsistence, their milieu. Art has taken a similar path: in Europe, the enclosure movement that began in the late sixteenth century coincides with the generalization of a private market for artworks that were mostly, up to then, produced for the community, for a milieu.[3] What is called the Golden Age of Dutch painting corresponds to the generalization, in the seventeenth century, of wide-scale agricultural land expropriation and the organized exploitation of the American colonies. As Meredith Tax argues: "In other periods of history, the artist has produced for a court, for a personal patron, for a religious sect, or for a political party. It is only with the dominance of the capitalist system that the artist has been put in the position of producing for a market, for strangers far away."[4] Drawn into the general movement of abstract

[3] The enclosure movement transformed agriculture in England from a system of cooperation and community toward private ownership, administration by a local lord. These seigneurial lands were exploited by employees, each field separated from the neighboring field by a barrier.

[4] Meredith Tax, "Introductory: Culture Is Not Neutral; Whom Does It Serve?," in *Radical Perspectives in the Arts*, ed. Lee Baxandall (Harmondsworth: Penguin, 1972), 22.

rationalization, art has nevertheless managed to preserve—unlike other fields of human activity—certain aspects of the social function and spiritualist practices of precapitalist societies, sometimes in clandestine or partial forms. Today, we must explore art history like a network of underground galleries, and suture sundered connections.

In my previous book, *The Exform*, I tried to show how modern art, starting with Gustave Courbet, established itself as the locus to which beings and things rejected by power could *return*; a centripetal force that brought back images or ideas to the public that were banished by power. These "exforms," products of cross-border negotiations between the excluded and the admitted, commodity and waste, manifested themselves in three major fields: ideology, psychoanalysis, and art. In my earlier book *Formes de vie*, I argued that the need to "make one's life into a work of art" was the true categorical imperative of artistic modernity. And a bit later, in *Relational Aesthetics*, I tried to theorize the way a new generation of artists, in the 1990s, used the interhuman sphere as a reservoir of forms that enabled them to rethink artistic activity.[5] In hindsight, I realize these three books described three facets of the artist as a figure of exception in the capitalist world, as an inventor of strategies of resistance to the productive sphere, as a resistance fighter against the domination of the labor theory of value. In each book, I outlined an *anthropology of refusal* describing practices through which art has preserved values buried or marginalized by the process of rationalizing existence, or by the extermination of the people who upheld them. Unlike work conceived and experienced in the capitalist economy, artists submit to no order but their own and produce objects in which they recognize themselves, projecting their own *person* onto them. Because of their modes of work, their sociological singularity, but above all the contents of their works, which can't be reduced to the ideology of productivism, the artists of the capitalist era are the heirs of the magicians, alchemists, and witches of the Middle Ages, and today they occupy an analogous position. But if the powers that be tolerate the presence of

<hr>

5 Nicolas Bourriaud, *The Exform*
(London: Verso, 2016), 201; Relational Aesthetics,
trans. Denyse Beaulieu (New York: Sternberg Press,
2007); *Formes de vie: L'art moderne et l'invention
de soi* (1999; repr. Paris: Denoël, 2009).

art at the margins of the system, it is because it does not constitute a direct threat: art is a way of expressing, from within the system, ideals that would inevitably be stifled if they emanated from a directly "productive" space. Today, how can we not see that what is expressed in contemporary art is the flame of the confiscated commons, stifled matriarchal traditions, abolished festivals and carnivals, banned vagrancy, animist magic and enchantment, bodies not subjected to logics of discipline, spiritualities connected with nature? To address the nature and reasons of this persistence, I will resort to the Melanesian concept of mana, defined by anthropology as a spiritual power, a symbolic efficiency borne by certain objects or persons. This impalpable object, endowed by Claude Lévi-Strauss with the quality of a "universal and permanent form of thought," draws fetishes and contemporary installations within the same space, that of an aesthetic resistance against the utilitarian and productivist ideology.[6]

 The West has forged an aesthetic principle that is the perfect illustration of Western binarism, born from the separation between nature and culture: the opposition between form and matter. It was first formulated by Aristotle (hylē, passive matter, receiving morphē, an active form) and perpetuated almost everywhere, for instance, in the aesthetics of Friedrich Schiller, for whom form represented the "spiritual principle" that shaped and ordered "amorphous" matter. Still today, this duality seems self-evident, but we can also perceive it as the subtlest and most pernicious of conditionings, the contribution of art to the binary thought that founds the Western mechanism of world domination. Where is the chicken, where is the egg? What is the primary cause of the chain of oppositions that has ended up conditioning the near totality of human life, which today's climate change compels us to respond to by dissolving them into a relational and inclusive vision of the world? What is clear is that matter, nature (disqualified as environment), women, the savage, the poor, and every nonstandard individual must submit to the will of the active principle, accept their condition as a medium to be formatted and subjugated. Hylē and morphē, such is the algebraic formula of

[6] Claude Lévi-Strauss, Introduction to the Work of Marcel Mauss, trans. Felicity Baker (London: Routledge & Kegan Paul, 1987), 53.

subjection, have been embedded in the theory of Western art for the past two thousand years.

What is the major effect of the Anthropocene, if not this awareness? After reducing the world to the state of a shop full of objects, we are now free to *repopulate it with active subjects with rights*. In the West, the very notion of a subject is based on a series of exclusions. We must now extend and disseminate it. As Anselm Jappe writes, "The origin of the subject-form is masculine, based on the model of the hierarchical relationship between soul and body, mind and nature, form and matter—as the etymology of the word 'matter' demonstrates: *mater*, mother."[7] The Western subject was shaped from undifferentiated feudal land, made up of a multitude of *nonsubjects* too "natural" to be integrated. In 2008, Ecuador was the first country in the world to recognize its ecosystem as a political entity, whose right to "exist, persist, maintain and regenerate its vital cycles, structure, functions and its processes in evolution" was written into the constitution. Nine years later, the parliament in New Zealand voted to give the Whanganui, a river considered sacred by the Maori, the status of personhood. The requalification of nonhumans into subjects of law (in other words, their shift from matter to form, from thing to person) is one of the major issues of the Anthropocene, while object-oriented thought, a recent philosophical movement celebrated as a salutary critique of anthropocentrism, can be seen as the Trojan horse of reification, a mental preparation for a new stage in carving up the planet at a time when multiplying the number of *persons* or subjects of law should be an absolute priority. Today, contemporary art (though it usually consists in putting an object in front of a human subject) is a laboratory in this respect: it is not restricted to exploring the processes through which humans are turned into things or data but also invents crossing points between various regimes of being and different forms of life.

With this book, I would like to contribute to the emergence of an *inclusive aesthetics* that calls for a training of the gaze, *decentered* at last, relocated finally within a plurivocal universe that includes nonhumans. Based on

[7] Anselm Jappe, *La société autophage: Capitalisme, démesure et autodestruction* (Paris: Éditions La Découverte, 2017), 55.

a broadened vision of anthropology, this aesthetics would validate the end of the dyads that structure predatory Western thought and even aim to completely dissolve them. In this inclusive aesthetics, form and matter constitute a sort of *cooperative* in the same way as human beings and what was once called, disdainfully, their *environment*. Thought, and especially artistic discourse, can no longer be content with the "critical" position to which they have been reduced. Instead of reacting to forms, images, or ideas with the tools we have inherited, we need to create new ones. To this end, we must integrate within all speculation on human aesthetics the beaver's dams, the bee's pollination, and the abstract designs of the butterfly. The latter composes forms on its wings organically, whereas the human being externalizes them and projects them—but aren't those simply different media? Since Lévi-Strauss, and those who have followed in his wake, anthropology refuses to approach the human being as an object, because an *object* does not exist outside its usefulness. Instead, it takes the world as a *subject*, addressing the molecules that compose it: tides and winds, forms of social life such as algorithms and silicon. This broadened anthropology, whose test pilot may well be the artist, embraces the fact that it is just as ambiguous as the term Anthropocene; in both cases, humankind is summed up by its effects.

We will start with the premise that artistic activity is subject to an *inclusive* reflection. Instead of treating it like a purely human exception with nature as a backdrop, artistic activity can be seen as an intense variant within all the signs emitted on the planet, and study it as the particular case of a general production that was pushed into the background, for ideological reasons, by the Western world. To do so, we will go back to the term from which the word "art" was derived, the Latin *ars*, which long had two meanings, now separate. *Ars*, according to Erwin Panofsky, denoted "man's ability purposely to produce things or effects as nature produces such objects and creatures as stones, trees and butterflies, or such phenomena as rainbows, earthquakes and thunderstorms. [...] The word [...] could be applied to the activities of any producer of things, as the architect, the painter, the carver, the embroiderer or the weaver; but also to the activities of any producer of effects, as the physician or the bee-keeper."[8]

Reconciling object and phenomenon, painter and beekeeper, will be one of the ambitions of this book. But far from advocating a return to precapitalist art and thinking, I will endeavor to show that new syntheses are under way, and that it is possible to extract from them the substance of a new modernity. In their recent developments, contemporary art and anthropology have undergone parallel evolutions, broadening their viewpoint to the nonhuman world. Many artists strive to represent or manipulate the elementary structures of life and the atomic component of social objects, thus turning *the maximum gap of visibility*, the contrast between the molecular and the molar, into the most noteworthy aesthetic event of the twenty-first century. To take a recent example, a pandemic is a paradigm of this maximum gap since it brings together particles invisible to the naked eye and massive objects, causing disruptions that are visible from a satellite in the human sphere, animal populations, or the atmosphere.

Amid the climate catastrophe, art could provide an alternative model and an inspiration for human activities. To be convinced, we only need to take a step sideways, toward so-called "primitive societies" that have integrated artistic activity into their everyday life. Observe how, in Japan, floral arrangement, cuisine, savoring tea, or setting the table are fully fledged art forms. Remember that in India, "painting and sculpture constitute a single and same category of art as cuisine, witchcraft and raising horses."[9] Or to step back into the caves from which the human species sent its first emission: prehistoric art, a mirror of the original chaos (the cave representing the world in its unfinished, incomplete state) and an expression of cohesion with animal life that is an early expression of totemism. Today, the ecological catastrophe challenges us to rethink the space our societies have assigned to art. Creativity, critical thinking, exchange, transcendence, the relationship to the Other and to history are many values intrinsic to artistic practice that will soon be of vital importance for the future of humankind. We need art to give a meaning to our lives—

[8] Erwin Panofsky, *The Life and Art of Albrecht Dürer* (Princeton, NJ: Princeton University Press, 1943), 242.

[9] Jindřich Chalupecký, "Art et transcendance," in *Duchamp: Colloque de Cerisy* (Paris: Union générale d'éditions, 1979), 21.

the banking system will not provide that. By attempting to unfold a few of the aesthetic figures floating in the global imaginary, this book intends to describe what is at stake in artistic activity in the age of the Capitalocene, and to argue for its acknowledgment as a *vital need*.

The Work of Art in the Age of Global Warming

THE ANTHROPOCENE, A RELATIONAL LANDSCAPE

It was through contemporary art that I first heard about
the climate emergency. More specifically, I learned that the
earth's atmosphere was related to human economy in gen-
eral and to our consumer habits in particular. The "Ozone"
exhibition, produced in 1989 by Dominique Gonzalez-Foer-
ster, Pierre Joseph, Bernard Joisten, and Philippe Parreno,
was an introduction to an original issue, addressing an un-
known object: a hole that was forming in the ozone layer up
in the stratosphere, which few people were then aware of.
The ozone layer, which protects us from the harmful effects
of sunlight, was a novel subject for art at the time.
Fortunately, since then, the infamous hole has shrunk, but I
have never looked at a spray can the same way again.

 The real lesson of this exhibition was not however
about activism, but about aesthetics, because it was con-
ceived as an ecosystem in which each testified to an ecolo-
gy of the image, taking in account their mode of production
and the milieu in which they circulated. Joseph laid out
giant slides representing digital models of nature; Gonza-
lez-Foerster set out folding seats and waste bins containing
articles about ecology, photocopies, postcards, and mag-
azines; Joisten showed hyperrealist vignettes of prehistory
featuring extinct species; Parreno hung up extreme-sports
accessories (a windsurf board, a paraglider, a wetsuit).
Without didacticism, the four young artists opened up a
novel mental landscape, at the eve of the digital age, in an
exhibition that "spread out in space like a gas," to quote
the formula they used to describe the coexistence of their
works. Outside, the artists installed a bag containing a col-
lection of objects that represented the main themes of the
exhibition in a portable version (*Le Sac Ozone*) and a video
shown on a giant inflatable television set (*Vidéo Ozone*),
which also evoked the ideas of the project. In short: a gas,
artworks pulverized into different formats, and a material
treatment of the image as a living species whose milieu
and modes of evolution should be considered. Anticipating
"molecular thinking," which will be addressed later in this
book, "Ozone" was also a forerunner of global awareness
related to what we now call the Anthropocene.

 The Anthropocene, which literally means "the age
of the human being," designates a new era in the history of
the earth that follows the ten million years of the

Holocene. There is nothing narcissistic about the reference to our species: it only points out the disastrous hegemony of humans over other species, the breadth and volume of our activities having a "geological force" capable of modifying the planet—no more or less than a virus. The term "Capitalocene," coined by the Swedish author Andreas Malm, underlines the fact that the threat *does* come from human activities, inasmuch as they are shaped by a profit-driven globalized production system and the privatization and intensive exploitation of natural resources.[1] What makes the clarification even more relevant is the fact that recent developments in contemporary art can only be understood in relation to globalized capitalism and its fundamental *anti-materialism*. Indeed, contrary to the generally accepted view, capitalism is in no way materialist; instead, it aims to *de-realize* the world in order to turn it into financial products, that is, into what Karl Marx called "universal equivalence," or currency. Its essence is financial, and the relations of production it imposes trade the actual experience of work against interchangeable bodies in neutral spaces performing actions conceived by other people. Capitalism is an idealism, or more to the point, a dualist philosophy that has progressively replaced the initial confrontation between soul and body with the implicit confrontation between living reality and its fiduciary translation. Bill Gates admitted once that he dreamed of a "friction-free capitalism" unfolding on the flat surface of a world that would, at last, be dematerialized. The dream of Microsoft's founder, of a smooth, flat universe, is increasingly becoming a reality.

Since Greenwich Mean Time was established as an international standard in 1884, humans have been subjected to the standardization of their pace of life. While a French miner of the nineteenth century could still organize his life as he pleased, and according to natural cycles, industry "trained" its employees to follow strict schedules that carried over into the night, thanks to electrical lighting, and to man assembly lines with three teams working eight-hour shifts. In 1911, Frederick Winslow Taylor's *Principles of Scientific Management* was published, a book that

[1] Andreas Malm, *Fossil Capital: The Rise of Steam Power and the Roots of Global Warming* (London: Verso, 2016).

encapsulates the program of industrial capitalism and lay the groundwork for Fordism: rationalizing space and time, turning the place of work into an abstract space and experienced hours into useable time, the flat and friction-free surface that is Bill Gates's dream. What Marx described as the "last natural condition" that opposed the total expansion of capitalist idealism, sleep and dream time, is about to yield to the imperatives of online life today, making us potentially available 24/7 for the great market.[2] How can we define the global lockdown imposed by the COVID-19 pandemic if not as the sanitary version of a process born out of the generalization of television in the 1950s, which induced people to stay at home in front of objects that supplied them with images? It has offered us a glimpse, via the standardization of private life, into the number of "frictions" the world system of capitalism could get rid of.

The friction that slows down exchanges is, in the first place, material reality—the weight of singular, concrete living things—for example, unemployed people, inconveniently located forests, and ice fields, where nothing that can be monetized grows. The blots on the ideal landscape described by Gates are also those elements with no monetary value: elements that form the basic components of our environment—liquids, powders, gases, fluids, minerals, insects, plants, rubble, filaments—and that the art of the beginning of this millennium has brought to the forefront. We have been seeing the world as a warehouse or a whirlwind of social or cultural facts for so long that we have forgotten that it is real and alive. Today's artists prefer chemistry and physics to objects, products, and things. The artist responds to the illusion of a "virtual" world, to the world without friction desired by Gates, showing the materiality of communication infrastructures, the origins of the constituents of an image on a tactile screen, the concrete logic of forms produced by the digitized economy. One of the main principles of today's aesthetics is the connection between different planes that official representations consider as separate, the creation of circuits putting different levels of reality into contact, bringing together spheres that are distant from one another in the common imaginary. Working with spiders, for instance, as Tomás Saraceno does,

[2] See Jonathan Crary, 24/7: *Late Capitalism and the Ends of Sleep* (London: Verso, 2014).

is an exercise in translation. One of his pieces, *Sounding the Air* (2018), is a musical instrument played by the wind, with sound frequencies produced by threads of spider silk as well as changes in room temperature, dust, or the presence of visitors.

But the climate crisis also points to a paradox: the more powerful and real the collective impact of the species is, the less individuals feel capable of influencing their surrounding reality. This sense of individual impotence goes hand in hand with the proven effects of the species that seem to come out of the blue, since our state of dependency on abstract, invisible, and faraway entities has made us forget how to interact with our milieu. Unlocking a car door requires electronic assistance, and heating our home depends on the extraction of fossil fuel at the other end of the world. In fact, environment and infrastructure are about to merge, and in this abstraction that is driven by a robotized technostructure, the human being is no more than a variable that can easily be dispensed with. Thus, we could define our new geological era as a period of crisis of the human scale, helpless in the face of a computerized economic system whose decisions are derived from algorithms capable of performing operations at the speed of light ("high-frequency trading" already accounts for nearly three quarters of financial activities in the United States). Human beings have become resigned to supporting an economy in which the human size is no longer relevant. Thus, we are witnessing the emergence of an unprecedented political coalition between the individual/citizen and a new subordinate class: animals, plants, minerals, and the atmosphere, all under attack by a techno-industrial system now clearly detached from civil society.

The word "Capitalocene" is appropriate for our current situation: the inhabitants of the globalized world have now been cornered into renegotiating the terms of their presence on the planet not only with all living beings, but also with their own technological creatures. "In the process of globalized competition," William Leiss wrote in 1972, "men become the servants of the very instruments fashioned for their own mastery over nature."[3]
The Anthropocene involves a new configuration,

[3] William Leiss, *The Domination of Nature* (New York: George Braziller, 1972).

a revaluation of our relationship with all the forces with which we cohabit.

It is not insignificant that more than thirty years after it first appeared, the internet now hosts more machine activity than human activity. In the beginning, the World Wide Web was seen as an instrument to liberate information, to generate togetherness and knowledge. But the ad servers, chatbots, and algorithms that process our personal data now represent most of the population of a space where the human species is tracked and reduced to the data that constitutes the economic stakes of our online presence. The more natural resources are exhausted, the more individuals turn into human resources, caught in a net that is an instrument of domination, just like the business world whose logic it duplicates. In this new relational landscape, we now have the same standing as fossil fuels, livestock, ocean water, or sunlight—as raw materials. Whether they are industrially produced or considered natural, things reflect human reality, sometimes even more so than humans themselves, since humans have trouble existing outside networks or events they are caught up in—or rather, since they have been reduced to an exchangeable workforce subordinated to a machine or an IT platform and consumers controlled by algorithms. Marx foresaw our status as an *appendage* of a system controlled by machines when he described the automated factory as "a mechanical monster whose body fills whole factories, and whose demon power, at first veiled under the slow and measured motions of his giant limbs, at length breaks out into the fast and furious whirl of his countless working organs."[4] The image used by Marx, that of a monstrous, whirling organism, can be compared to recent descriptions of Gaia: the planet as a living being, as a dynamic physiological system.[5]

The control of time by the tentacular monster, which Marx also calls the "automaton," is just as elaborate as its mastery over space: first and foremost, productivism translates into a new division of time, into timetables and rates. Today, the Anthropocene enables us to rethink

[4] Karl Marx, *Capital*, vol. 1, chap. 15, https://www.marxists.org/archive/marx/works/1867-c1/ch15.htm.

[5] James E. Lovelock, *The Ages of Gaia: A Biography of Our Living Earth* (Oxford: Oxford University Press, 1988).

the abyss that separates us from natural rhythms. Between time immemorial and an explosion, the geological and the disposable, the milieu in which we live now reflects the temporal dimension of human space, and a natural setting shaped by the myth of acceleration. According to John Zerzan, this goes back to prehistory: "Time as a materiality is not inherent in reality, but a cultural imposition, perhaps the first cultural imposition, on it."[6] What we used to call the environment is made up of (artificial) rhythms as well as living beings. We thought that we lived in a museum and that we were its curators—though oddly unconcerned by the condition of the reserves; now we find ourselves onstage in a play written by a mysterious collective, with plot twists made up of disappearances and appearances, slow erosions and sudden extinctions.

ART AS SUSTAINABLE ENERGY: A THEORY OF THE PROPULSIVE FORCE

Art historian Aby Warburg was the founder of modern iconology and the ethnologist Claude Lévi-Strauss that of structural anthropology. Both were great thinkers of distance. Their respective works also express a certain pessimism about globalization, a catastrophist vision of the global promiscuity brought on by technical progress. After his lengthy stay among the Hopi Indians in 1896, Warburg wrote: "The telegraph and the telephone destroy the cosmos. Mythic and symbolic thought, with its attempt to spiritualize the link between man and the surrounding world, create the space for prayer or for thought that instant electronic contact kills."[7] The "cosmos" Warburg speaks of is an open space comprising long distances (the "faraway") and the *elsewhere*; in other words, the opposite of the digital immediacy that crushes time and space on screens

[6] John Zerzan, *Future Primitive Revisited* (1994; repr. Port Townsend, WA: Feral House, 2012), 7.

[7] Aby Warburg, *Le rituel du serpent: Récit d'un voyage en pays pueblo* (Paris: Éditions Macula, 2003), 133.

[8] Walter Benjamin, *The Work of Art in the Age of Its Technological Reproducibility*, ed. Michael W. Jennings, Brigid Doherty, and Thomas Y. Levin, trans. Edmund Jephcott et al. (Cambridge, MA: Belknap Press of Harvard University Press, 2008).

today. Walter Benjamin used similar terms to define the *aura* of the work of art: "the unique apparition of a distance."[8] But today, signals travel at the speed of light; the speed of chains of consequences matches the speed of human emissions, played on a loop on social media. What is left of the power of art when instantaneity tends toward the absolute, when distances dissolve, inducing an unprecedented mix of human cultures? As Warburg explains, "The conscious creation of a distance between oneself and the outside world is what we can probably designate as the founding act of human civilization; if the space thus opened becomes the substrate of artistic creation, then the conditions are fulfilled for this consciousness of a distance to become a permanent social function [...] whose capacity or powerlessness to orient the mind means no less than the destiny of human culture."[9] Taking a step back, the term "cosmos" can apply to both the physical and the psychological world.

In *Race and History* (1952), Lévi-Strauss sounded the alarm about the uniformization of the world. The phenomenon we call *progress*, he explains, has led to the domination of the world by the West because of its technical superiority. But if we examine it more closely, this history is no more than a series of coincidences. Or to be more precise, an accumulative process based on intermixing and exchange: it was only because of its extreme social and cultural diversity within a confined geographical space that Europe got the upper hand over other civilizations at the end of the Middle Ages and could initiate colonization. When the distances between cultures lessen, fuel runs low because there is less "differential potential." But this theory, which I believe to be correct, can also be read in a negative way as soon as it is transposed onto a purely political plane. Diversifying the social body (like capitalism, which developed by constituting a proletariat) or incorporating outside elements into it (like colonialism, which industrializes slavery) were attempts to regenerate the *differential*, that is, that which is indispensable to growth: social segregation and the annexation of faraway countries also have energetic causes, since economic growth is based on an initial

[9] Aby Warburg, quoted in Karl Sierek, *Images oiseaux: Aby Warburg et la théorie des médias* (Paris: Klincksieck, 2009), 40.

segregation that fuels it with differential energy, the same principle as an internal combustion engine. Lévi-Strauss aimed to demonstrate that "the true contribution of cultures does not reside in the list of its particular inventions, but in the differential gap between them."[10] It is the interplay of intercultural distances, within relations of cooperation and mutual borrowing, that is the "engine" of artistic production. Since fusion can only produce magma, how could such differential gaps occur today? It was in this sense that I called the artistic practices that oppose the uniformization of the world in the age of globalization "altermodern": art resists general standardization by producing singularities, distancing itself from cultural norms, mixing traditions and hybrids. The art of the twenty-first century will be creole or will not be.[11] There is no cultural appropriation but rather more or less legitimate modes of use of exogenous cultural signs.

Georges Bataille, after learning about the Lascaux cave paintings, wrote that "their meaning was in their apparition, not in the durable object that remained after the apparition."[12] The frescoes on the cave walls of Lascaux and Altamira confront us with human society as it existed thousands of years ago, short-circuiting time: the work of art is a trace that possesses the power to create a fold in time, joining the past and the now – it creates a differential. For Bataille, its specific character rests on the existence of a symbolic *distance* in space or time. The force of the apparition, which creates its value, is equivalent to the eruption of the faraway into the near; it is its capacity to dig through our present, like a wormhole leading to another planet, a kind of antimatter. Barnett Newman says something similar in "The Sublime Is Now": the work of art, he writes, reveals itself in the "now" that creates its being and relates to an anthropological reality, namely, for the American painter, the Native American rituals once studied by Warburg.

[10] Claude Lévi-Strauss, *Race et histoire*, Folio Essais (Paris: Gallimard, 1987), 76.

[11] See Nicolas Bourriaud, *The Radicant* (Berlin: Sternberg Press, 2009).

[12] Georges Bataille, "The Passage from Animal to Man and the Birth of Art," in *The Cradle of Humanity: Prehistoric Art and Culture*, ed. Stuart Kendall, trans. Michelle Kendall and Stuart Kendall (New York: Zone Books, 2005), 77–78.

But the disappearance of the notion of the *original* in our contemporary regime of endless duplication tends to abolish both the past and the present of the apparition, in other words, the distance that once created the aura of the work of art. We are now on the same plane as signals, immersed in an endless proliferation of images that are not based on the past and don't even aspire to last. Weak, rotating on-screen signals playing on a loop: the life span of images seems to be withering, as though they had run out of the fuel that is distance. How can art regain it?

From Paleolithic cave paintings to the present, the artistic sphere could be defined as a *space* that allows the emission and reception of signals. Indeed, art is neither a mere image (abstract art offers none), nor a material thing (art is not necessarily material), nor an act of *communication*: it can only be defined as a "relational regime," a specific way of understanding reality, used by humans to sometimes mysterious ends. Warburg's assertion that "instant communication destroys the cosmos" becomes clearer when it is related to his *energetic* conception of the work of art, defined as a "dynamogram," an active trace. Elaborating on his idea, we can admit that every artwork consists in emitting a signal that will stay the distance of time (or the space between two civilizations) through the energy it produces; that will resist entropy (and therefore insignificance, oblivion, its fate as *waste*) based on its capacity to produce energy usable by the beholders of the future. This energy, which could be likened to a *propelling force*, creates the only universal definition of what Westerners have chosen to call "beauty," that is, a combination of formal mastery and visual and intellectual complexity, the artist's capacity to encode information and sensations within matter (or time) and render the mindset of his or her era. If these conditions are met, so is the work's potential to enter a dialogue with its present and future receptors. An artwork is durable if it regularly renews its capacity to interact with human beings, as though it could connect over the years with different sources of energy. In other words, a durable artwork will always manage to connect with changing intellectual and sensible contexts: through what it captures of its time and what it anticipates for the future, its form will go on *speaking* to us, generating ideas and visual derivatives that others can communicate with—an "infinite conversation," as it were. The life of artworks is made of increases and

decreases in intensity, depending on the cultural context they go through. It is in this sense that Marcel Duchamp could assert that "the beholders make the picture." If our conversation with an artwork is interrupted, it disappears, turning into clutter. But have we ever stopped conversing with Giotto, with Vermeer, with Shitao, with Yves Klein?

For artists who are historically closer to us, our dialogue has not yet stabilized; for others, it might resume when a new ideological constellation emerges. Today, the evolution of mentalities, namely concerning the history of colonized peoples or the advances of feminism, allows us to rewrite the history of art by including artists such as Artemisia Gentileschi and Georgia O'Keeffe, the Indian painter S. H. Raza, the Puerto Rican painter Francisco Oller, or the Ivorian artist Frédéric Bruly Bouabré; that is, to engage in "conversations" interrupted by outdated prejudices or partial visions of the world. The wavelength that carries an artwork today can, however, be scrambled by other forces tomorrow, because our gaze is dependent on the evolution of ideas or tastes, the interests of the era, its geopolitics. The only artworks that survive are the ones that manage to truly *encapsulate* their era and to generate, at the same time, the complexity of their content, multiple *angles of dialogue* with later periods. Responding to the active forces of its times is the least an artwork can do, but merely illustrating them will limit its power. Each artist must desire to compose a representation of the spirit of an era and his or her level of resistance to it, and this dosage seems crucial to ensure the durability of an artwork. But we cannot cast aside the countless artistic actions whose circulation in the social body is more modest, within smaller communities, that aren't circulated in the market, put on exhibition, or included in collections. The energy of the signal can also dissipate, *leak* outside conservation systems to circulate within its era, for a limited public, and that's fine too.

When Jean-François Lyotard defines painting as a "chromatic inscription" consisting in "connections of the libido onto color," he is also saying that art comes under an energy policy.[13] The artwork is an apparatus, a *transformer* whose power depends on the quality of the materials it incorporates and the capacity of the artist to process them.

[13] Jean-François Lyotard, *Des dispositifs pulsionnels* (Paris: Christian Bourgois, 1973), 235.

For Warburg, each artistic act endeavors to constitute what he calls a *Denkraum*, a mental space, a place for thought. And every image is *intermediary*, in other words, it acts like a link: "It is a matter of establishing between the force of nature and Man a connection, that is to say the *symbolon*, a connecting element, the act of magic that establishes concrete connections by delegating a mediator."[14]

It is the existence of this connection that leads Warburg to define the work of art as a dynamogram: a form that has registered the passage of a force—every form being the trace of an energy. Rather than restricting himself to the meanings deliberately expressed by the artist, like classic iconology does, Warburg analyzes all the forces at work in an image. My conviction is that today's art can only reinvent itself by being on the lookout for the new forms of energy offered by the global promiscuity generated by the Anthropocene and the era of pandemics with which we are confronted. New short-circuits and new vicinities are appearing; every distance is being reconfigured. Art is a sustainable energy whose place has long been at the center of human societies, and contemporary anthropology confirms this idea. Beyond satisfying an aesthetic need, art reveals the principles that organize space within a society, how knowledge is transmitted and how signs circulate.

THE DENSIFICATION OF THE WORLD

Today, the catastrophes of the Anthropocene draw spheres that were once disconnected in Western cultures closer together. It delineates, by the *folds* it forms on Earth, a new topology in which plastic and the oceans, the ice shelf and carbon, the tropical forest and bats, the health system and consumers of Nutella are brutally connected. Ecosystems touch one another, interdependences are visible to the naked eye, and the palpable distance that separates each human from the rest of the living world becomes shorter with every day. Who can see a Q-tip or a plastic cup the same way as before? The COVID-19 pandemic has demonstrated that a market in Wuhan can have an impact on the World Bank, temporarily lower atmospheric pollution, and regulate the distance between human beings. Distance is an elastic concept, and our space is evolving at high speed.

[14] Warburg, *Le rituel du serpent*, 93.

Thus, Anna Tsing suggests that the sign that we have passed from the Holocene to the Anthropocene may well be the disappearance of refuges where species can reconstitute after major events—such as the gigantic fires of 2019/20 in Australia, desertification, or the building of highways in the Amazonian forest.[15] In an essay that takes bodies of water as the intersection between feminism and ecology, Astrida Neimanis points out the stunning level of polychlorinated biphenyls in the breast milk of women of the Arctic regions, reconstituting a toxic chain that goes from factories to rivers, from rivers to acid rains and wind, to end up in the oceans and the food chain.

The disappearance of distances leads to density. "Images and messages," Jean Baudrillard wrote, "have become so proliferating, undifferentiated, impossible to select, that they end up prohibiting any exchange."[16] In the world of industrial hyperproduction, where waste accumulates without any possibility of being recycled, overload becomes a crucial element: Knowing that all thinking implies generalizing, and therefore choosing to forget, how can we *think* in a saturated space-time? A world where nothing is lost is a world that condemns thinking. In the world of silicon, smartphones, and social networks, signals agglutinate to form a sort of geological stratum: each word, each image, acquires a mineral density that gives our civilization the illusion of constituting an unchangeable and definitive landscape, like the mountains of garbage whose monumental sizes are constituted from millions of tiny scraps. The recording industry has merged with communication flows; to be is to record oneself. No presence can be considered *intense* if it does not imply its own obliteration. Our present, made of watermarks and pixels, has become spectral, while human memory has turned into a storage warehouse riddled with dark and interchangeable aisles. In today's clutter, our relationship with the artworks of the past is no longer determined by the vagaries of a cultural context made of ruptures and recoveries, as was the case up to

[15] Anna Tsing, "Feral Biologies"
(lecture, Anthropological Visions of Sustainable
Futures, University College London, February 2015).

[16] Jean Baudrillard, "L'antidote au mondial est du côté
du singulier" (2008), in *Entretiens*
(Paris: PUF, 2019), 419.

now, but by a hypermnesic cacophony in which we record ourselves recording.

This cluttered landscape has generated the phenomenon of *compulsive salvaging*, which translates, for instance, into the encyclopedic ambition of certain exhibitions. Huge collections of objects or images form the basis of the approach of many contemporary artists, whose works consist in targeted archiving: the quest for exhaustiveness acquires aesthetic qualities, the museum is presented as a format, the archive as a mode of composition. The fact that no visitor can take in installations so abundant that his or her gaze will ever be able to circumscribe them, or his or her imagination ever take stock of them, has the merit of offering a contemporary equivalent of the *aura* of the artwork, whose loss Walter Benjamin lamented. Yesterday's metaphysical "faraway" is supplanted by infinite lists and warehouses; density supersedes intensity. Within this mass of information and objects, the postproduction strategies developed by artists since the past century are addressing political material more directly today through the notion of sustainable development and the ethical principle it entails (salvaging, recycling).[17] Thomas Hirschhorn's installations, colossal masses of documents collected around a theme or an author, in environments themselves made of salvaged materials, constitute the paradigm of this *sublime archivism*. But this paradigm rests on an increasingly threatening paradox: while a monsoon of images washes over social networks and tsunamis of cultural products rush out of Amazon's warehouses, the artwork now survives in arid, even deserted zones. On the one hand, an invasive swarm of images and objects; on the other, a decreasing intensity in the responses they elicit. Today, if there's one thing we're short on, a commodity that has become scarce, it is the active gaze of human beings on artistic forms—the gaze that makes the work of art exist because it is *answered*.

As an effect of this general overproduction, the notion of pollution now dominates the contemporary imaginary. A thick layer of visual smog surrounds us, a toxic-looking fog made of an exponential mass of images. In the imaginary of the twenty-first century, cultural products

[17] See Nicolas Bourriaud, *Postproduction: Culture as Screenplay* (New York: Lukas & Sternberg, 2005).

tend to form an autonomous layer, like the masses of plastic that invade our oceans. This dread of pollution translates into strange conceptions of intercultural relations, as shown by the recent debates about "cultural appropriation," an expression that seems to infer the existence of a "pure" culture, reflecting an essentialized identity. Western ideology, based on private property and binarism, finds unexpected partners in these artistic practices based on the sacralization of identities. By using the term "cultural appropriation" we tend to negate the circulation of ideas and forms in the name of an ethics of exclusive use rights, thus validating the ideological marker of capitalism under the guise of denouncing neocolonial abuses. Furthermore, these recent debates mask a fundamental power relationship, that of human beings over all nonhumans. Worse yet, they obliterate any attempt to reflect on a global ecosystem in which fair exchange would take precedence over the private property of cultural or natural elements. With these Byzantine quarrels, we now realize the limits of an artistic conversation that has become autarchic, in other words, disconnected from a space exterior to the human—cut off from the cosmos, to quote Warburg. As a response to economic globalization, art has focused on the issues of power, norms, and cultural differences since the end of the twentieth century, unfortunately leading to debates between ever-more segmented human groups. By refusing anything that may resemble, directly or indirectly, the *universal*, that is, a shareable space, we end up not only considering cultural specificities as private properties, but also failing to address the way in which the human species subordinates all living beings. Anti-universalism turns out to be the ultimate refuge of classic humanism: the only credible alternative is a genuine intersectionality operating between these sectorial confrontations.

The humanization of the entire planet, the massive production of objects whose obsolescence is planned, the promiscuity of clashing cultures: from this novel situation, art must learn to extract the *differential energy* of which Lévi-Strauss spoke, the spark ignited by the shock between two pieces of flint. The anthropologist reminds us that art is not merely the presentation of a culture, but "also a guide, a means for instruction, [...] for learning about reality as it is."[18] Lévi-Strauss uses a concrete example: after the grandiose landscapes where human figures stood

in classical painting, the Impressionists chose suburban landscapes, "a field, a little house, a few scraggly trees" and focused on "the fleeting aspect of things" rather than the sense of permanence that was sought by art in earlier centuries. This is, Lévi-Strauss explains, the painting of a society that is learning to renounce a certain living environment. Soon afterward, Cubist painters showed our "coexistence with the products of human industry" and painted a world henceforth "completely occupied by culture and the products of culture," before a need to escape from common spatial coordinates was expressed through abstract art.[19] Claude Monet, with his random framings and series, fragmenting landscapes, standing before them at various times of the day like a camera, belongs to the generation of artists who foresaw the possibility of a nonhuman gaze on the world. With Monet's *Water Lilies* series we find ourselves in the middle of a pictorial space that dispenses with the human gaze. Today, Gerhard Richter, by moving indiscriminately from abstraction to hyperrealism, like a constantly readjusting microscope, is heir to the line of artists who negotiated their relationship with the world through machines, translating their horror of promiscuity by displacing subjectivity outside of the gaze itself. But how can we describe the relationship of today's artists with the outside world? Through what apparatuses do they perceive their milieu?

First, the geography of the Capitalocene can be characterized as being *exhausted* for the first time in history. It is an image with no fuzzy areas, pixelated by satellites and mapped out down to the last rock. In 1932, when this process was not quite finished, the poet Paul Valéry reflected on the consequences of the total annexation of the planet by human administration. Because it marked its period, I will quote the whole passage:

> Every habitable part of earth, in our time, has been discovered, surveyed, and divided up among nations. The era of unoccupied lands, open territories, places that belong to no one, hence the era of free expansion, has ended. There is no rock that does not bear a flag; there are no more blanks on

[18] Georges Charbonnier, *Entretiens avec Claude Lévi-Strauss* (Paris: Presses Pocket, 1961), 164.

[19] Charbonnier, 167.

the map; no region out of reach of customs offi-
cials and the law; no tribe whose affairs does not
fill some dossier and thus, under the evil spell of
the written word, become the business of vari-
ous well-meaning bureaucrats in their distant
offices. The age of the finite world has begun.
The general census of resources, the gathering of
statistics on manpower, the development of media
of communication are all under way.[20]

This general movement extends the colonial project by
disseminating it, making it everyone's business and marking
the definitive loss of the elsewhere under the onslaught
of "humanist" uniformization. Our twenty-first century is
confronted with the effects of this "finite world" to such
an extent that its geography is being shaped by a gigantic
force: density. Human overpopulation creates new "folds"
in ecosystems, unprecedented vicinities and collisions.
Deforestation puts wild animals and livestock in contact,
offering new chains of transmission to deadly viruses. And
during the COVID-19 epidemic, making "social distancing"
the global watchword facilitates the control of our relational
space and is even likely to reshape contemporary cities
according to its logic. Incidentally, the generation of artists
that used the sphere of human interactions as a formal ma-
trix in the 1990s anticipated, without realizing it, the issues
raised by the climate catastrophe. The rational occupation
of the "finite world" as a mere surface to be exploited,
based on the competition of all against all, has led to the
disappearance of common spaces in the city, owing to, for
example, the fences put in place to keep the homeless from
sleeping in parks, benches designed so that no one can lie
down on them, the order to shelter in place. Since the land-
use plan of the finite world no longer includes intermediate
zones or preserves, the side effect of this logic of density
has been to spray the entire surface of the planet with cul-
tural signs. We can find ourselves in Mexico in the heart of
Paris, in China in a New York neighborhood, in Vienna under
a monsoon rain. Places are no longer anchored to physical
territories because they are cultural markers that can occu-
py whatever enclave is set up for them. Thus, thanks to

[20] Valéry, *The Outlook for Intelligence*
(Princeton, NJ: Princeton University Press, 1962), 15.

hydroponics, crops can be planted in greenhouses all across the earth.

The art of the twenty-first century expresses this promiscuity between species and spheres—the effect of an overcluttered world. Nowadays, it is striking to see how no single material, no technique, expresses the unity of a culture: heterogenous styles coexist, even within homogenous societies, circulating all over the world. This unique situation in history leads us to believe that today's art is an art of global promiscuity, arising from increasingly kaleidoscopic societies. The assessment applies to the whole planet; to reflect their times, artists can work anywhere. The less you show a specific place, the more you show an era that is all about being uprooted from places and territories. As examples, I will take three artists, each of whom proposes a radical formal definition of the contemporary individual: Ambera Wellmann, Paul Chan, and Tala Madani.

In Ambera Wellmann's paintings, human bodies are most often entangled in erotic encounters that dilate and scatter them. The Canadian artist places chromatic blocks on monochromatic surfaces; her figures are not set against backgrounds, even though certain details may sometimes allow us to locate them in a room or on a bed. Outlines don't always match the surfaces they define; some stop halfway through a form, others ramify or dwindle off into moist or brilliant effects, where flesh may look like porcelain. Spatial geometry has vanished, and there is no up, no down, no right, no left, no planes or volumes: Wellmann represents a world after the big bang, a primal soup where contemporary bodies are immersed, interpenetrating each other while absorbing the things and beings that surround them.

Paul Chan does the opposite, representing the human being as an empty envelope. Made of fabric tubes connected to noisy blowers that make them gesticulate continuously, these figures (the artist calls them "breathers") are a literal expression of *pneuma*, the word used by Aristotle to designate the vital breath, the soul, or the spirit. Pneumatic, full of wind, the human being according to Chan is only animated by machinery. But does it wave around because it is caught in a storm? A two-channel animation produced by Chan at the beginning of his career, *My birds...trash...the future* (2004), shows humans, birds, and dogs carried off by gusts of trash-filled wind.

The more recent sculpture *Pentasophia (or Le bonheur de vivre dans la catastrophe du monde occidental)* (2016) features the ghostly characters from Samuel Beckett's play *Quad* (1981) arranged like the figures in Henri Matisse's *Dance* (1910), which evidently inspires Chan's ironic title. Hollow and passive, Chan's humanoids are thrust into a Sadean catastrophe, in the mechanical fury of exploited bodies. Chan has actually dedicated a long video to the Marquis, *Sade for Sade's Sake* (2009).

There is similar violence in the work of Tala Madani, who also produces animated films featuring bodies (most broadly resembling Middle Eastern men), but in an abstract, burlesque world. Each of her paintings seems to emanate from a single scene: she needs an "abstract space," she explains, "a variable space where any action becomes possible."[21] The Iranian-born American artist shows the inhabitants of a totalitarian world whose occupants seem to obey a tendency toward violence. They have swapped their interiority for the display of their waste or urges under violent lights, like puppets in a slaughterhouse. But if Madani's paintings reinvent human representation, it is through her treatment of light and color, to which she substitutes a wide range of visual special effects. Her power comes from this scenographic signature: her subjects, human figures sketched out with an irregular line or reduced to the luminous halo that outlines them, are immersed in a thick darkness pierced by blinding spotlights, surrounded by pallid computer screens, encircled by the brutality of mobile-phone flashlights or policemen's torches. In Madani's work, light is a source of oppression, and the human being is a puppet that happens to be, simultaneously, a murder weapon and inanimate matter.

Since contemporary art can reflect or show without compromise the physical and mental stifling of contemporary societies, it occupies, wherever tradition no longer regulates representation, the place of Cassandra or the position of a pariah.

[21] Quoted in Kevin McGarry, "Greater New Yorkers: Tala Madani," *T Magazine*, June 2, 2010, https://tmagazine.blogs.nytimes.com/2010/06/02/greater-new-yorkers-tala-madani/.

NEITHER NATURE NOR CULTURE

The status a society confers on nature and the resulting modes of representation are an exact reflection of the human relationships within this society. This is why the notion of the Anthropocene functions as a symbolic projection. Before being a scientific fact, it is the fulfillment of an ideological program: the unbridled exploitation of natural resources is the outcome of a philosophy, and the planet's current condition reflects our cultural choices. This program rests upon what Philippe Descola calls "the three conjoined divinities" of the Western world: (technical) efficiency, (economic) profitability, and (scientific) objectivity. These divinities, more discreetly venerated but just as real as those of the Navajo people or the ancient Greeks, go hand in hand with a conception of nature as objective, cold, and broken down into physicochemical units. What anchors this ideology is the theoretical separation instated in the past by humankind between its species and its natural environment, that is, the whole of nonhuman life. We find its foundation in the book of *Genesis*, verse 26: "That they may rule over the fish in the sea and the birds in the sky, over the livestock and all the wild animals, and over all the creatures that move along the ground. [...] God created man and woman. [...] And told them: Be fruitful and increase in number; fill the earth and subdue it. Rule over the fish in the sea and the birds in the sky and over every living creature that moves on the ground."

The separation between man and nature would be reinstated in the seventeenth century by René Descartes, who enjoined humans to become "masters and possessors of nature" and divided reality into the mind (*res cogitans*) and the physical world (*res extensa*). Then it was confirmed by Charles Darwin's theory of evolution, itself used to legitimate the domination of the winners of natural selection over the animal realm. An instrument of exploitation and domination, the ideological separation between nature and culture is the key to the technical ascent of the European continent, but also the matrix of every discrimination policy. Thus, it has anchored within Western mentalities the gendered division of labor (with women relegated to the side of "nature") or colonialism (through the rhetoric of the "civilized man" and the "savage"), before leading to the environmental and climate catastrophe we are experiencing today.

Humans and nonhumans are brought together at last under the disastrous aegis of the Anthropocene, this time as subordinates, mere materials subjected to a technoeconomic apparatus that is the true master of the universe—the ideology of profit ("value" and "growth") have become the true subject of history. In the same way as a plant from the Amazonian forest or a grain of wheat are turned into patented products by companies, the "personal data" left by individuals on social networks is harvested for mercantile purposes. Like a science-fiction movie that has turned into the reality of geology and climate, the Anthropocene is a historic moment in human relations. The global climate crisis, before being a physical phenomenon, is the translation of a social and political state of things, the consequence of philosophical choices. In his *Treatise on Man* (1664), Descartes established a radical distinction between the mental and the physical. The human body is a robot that can be dissected, a set of mechanical parts meant to shelter a soul. How better to prepare the world for industrialization and production than the invention of the worker that is required for it? The "vile instincts of the body" and its nefarious "passions" arise from "nature," whose manifestations must be fought off by the individual and quashed by social rationalization.

But this program of submission of the living to the needs of the cult of productivity would have been impossible if nature and culture had not been absolutely separated. Western physics developed in the fifteenth century around a new paradigm, the *experimental method*, which imposes arbitrary and artificial laboratory conditions to nature, so that natural materials can be manipulated to achieve a certain goal: verifying a theoretical hypothesis and proving it rationally. Within this apparatus, the living is reduced to a set of abstract, separate elements: organs, atoms, and molecules, then bit, pixels, the binary language. The classical age of Europe contains the seeds of computation and the digitization of reality, and the twenty-first century's computerized rationality truly stems from the rise of experimental physics. François Jullien's comparatist works between ancient Greek and Chinese philosophy show that this premise and its methods, while they allowed the technological progress of Europe, are the opposite of the Chinese mentality of the era, centered around the notion of *shun* ("to espouse, to be connected to the flow of things").

Dissecting a natural phenomenon held no interest for a Chinese man of letters in the eighteenth century, who saw what Europeans called "nature" in terms of interactions and harmonic regulations but certainly not as a neutral "container." Analytical decomposition, which is a specific mode of representing the world, united arts and sciences in the West. The emergence of productivist reason cut the world in half, gradually erasing from European minds the memory of the "analogy between the human animal and the earth he inhabits,"[22] at a time when the earth was conceived as a living entity teeming with signs, when the individual believed "its flesh is glebe, its bones rocks, its veins great rivers; its bladder is the sea and its seven main limbs, the seven metals that hide deep at the bottom of mines."[23]

How can we think art, how can we envision a future for it beyond the historic coup de force that led humankind to exclude itself from nature, without adopting backward-looking reflexes? The weak reaction would consist in taking the opposite stance to anthropocentric humanism, taking the side of things and diluting the human into natural phenomena. But it seems bolder to move beyond both these outdated conceptions and their overly symmetrical antithesis. And as it happens, the historic moment we are experiencing is favorable to such a move. On the one hand, the Anthropocene has made humanity accountable in a way that could lead to a global refoundation of ethics through the mobilization of all human beings, whatever their cultural *habitus*. On the other, it is accelerating a movement already initiated by the avant-gardes, leading the West to turn to modes of thinking it has contributed to destroy all over the planet. Art has been a forerunner of this new cultural paradigm, at least since the 1960s. And since the point today is to contribute to the emergence of a theory of art that acknowledges that we have moved beyond the division between nature and culture, a contemporary art of the event that bears the name of Anthropocene, we must rethink the position of artistic activity within the chain of beings and things.

[22] Michel Foucault, *Les mots et les choses: Une archéologie des sciences humaines* (Paris: Tel Gallimard, 1966), 37.

[23] Oswaldus Crollius, quoted in Foucault, 37.

 If we had read Claude Lévi-Strauss more close-
ly, we might have seen that anthropology took a decisive
turning point in 1962. A footnote in *The Savage Mind*: "The
opposition between nature and culture to which I attached
much importance at one time now seems to be of primarily
methodological importance."[24] He even adds: "The oppo-
sition [nature vs. culture] is not objective, it is men who
felt the need to formulate it."[25] And if the author of *Tristes
Tropiques* operates this conversion slightly ahead of his
colleagues, it is because his comparative work on myth led
him to a *monist* view of the universe: he concluded that
"the mind operates in ways that do not differ in kind from
those that have unfolded in the world since the beginning
of time."[26] He also elaborates on an argument that allows
anthropology to break away once and for all from ethnolo-
gy, the study of so-called primitive people: the point is "the
reintegration of culture in nature and finally of life within
the whole of its physico-chemical conditions."[27] Nothing
distinguishes the human being from his milieu, nature being
the "biological framework" of the world: for Lévi-Strauss,
the universe is indivisible, from quartz to the human brain
and from bacteria to the leaf of a conifer. Human thought is
a natural production, like the fruit of a tree. In other words,
anthropology has become a thought of *decentering* that
dissolves our conception of the human being as a sub-
ject separate from the living world. Lévi-Strauss was also
among the first to denounce humanism:

[24] Claude Lévi-Strauss, *The Savage Mind*
(London: Weidenfeld & Nicholson, 1966), 247.

[25] Lévi-Strauss, quoted in François Dosse, *Histoire du
structuralisme*, bk. 1, *Le champ du signe, 1945–1966*
(Paris: Éditions la Découverte, 1991), 315.

[26] Claude Lévi-Strauss, *The View from Afar*, trans.
Joachim Neugroschel and Phoebe Hoss
(London: Penguin Books, 1985), 118–19.

[27] Lévi-Strauss, *The Savage Mind*, 247.

[28] Claude Lévi-Strauss and Didier Eribon, *De près ou
de loin, entretiens: Suivi d'un entretien inédit "Deux
ans après"* (Paris: Seuil, 1991), 225.

[29] Eduardo Viveiros de Castro, *Cannibal Metaphysics:
For A Post-structural Anthropology*, trans. and ed.
Peter Skafish (Minneapolis: Univocal, 2014), 48.

"By isolating man from the rest of creation," he writes, "Western humanism [...] has deprived him of a protective buffer," since "once man stops knowing limits to his power, he goes on to destroy himself."[28] In the same sentence, he refers to extermination camps and the climate catastrophe.

THE GREAT DECOLONIZATION, FROM THE "NEW WORLD" TO THE "SEVENTH CONTINENT"

Those who might question the relevance or legitimacy of my undertaking—that is, a reading of the Capitalocene, anthropology, and decolonization in the light of aesthetics—should be reminded of a historical truth. It is in the world of art, in the early twentieth century, that colonized cultures were first acknowledged, more than four centuries after the invasion of America by Christopher Columbus or the destruction of the Aztec world by Cortés. It is through Fauvism, Cubism, and then Dadaism that African sculpture entered art history, exiting curiosity shops and the windows of ethnological museums. It is thanks to Surrealism that the world of forms extended to the masks of New Hebrides (now Vanuatu) or the monuments of Easter Island, that the shields or fetishes of non-Western peoples were considered from an aesthetic standpoint. It is also because the pioneers of abstract art broke with Europe's vernacular passion for realism that it learned to read and comment on, not just "scientifically," the visual grammars of the whole world. Neither anthropologists nor philosophers or political thinkers played a major role in this drawn-out process for recognition. It was the artists, from Paul Gauguin to Joseph Beuys, who allowed so-called primitive cultures to reintegrate the global narrative of history, and who showed European thought for what it was: a specific and local vision, neither more nor less valid than others. Yes, art does have its word to say about globalization and the Capitalocene. And today, this accumulated knowledge lets artists sustain a genuine dialogue with anthropologists.

Over the past decades, anthropology has taken two turns by jettisoning both its anthropocentrism and the phantoms of colonialism. Brazilian anthropologist Eduardo Viveiros de Castro defines his practice as a "permanent exercise in the decolonization of thought" that concerns conquered and oppressed peoples as much as all species.[29] The core of the colonial project was human control over

the living world; its primary principle was the *naturalization* of the other, denying their point of view, excluding them from the community of subjects of law. In this, plants, animals, and colonized people were victims of a similar treatment. Philippe Descola's work on the artificial (but very opportunistic) Western division between nature and culture shows us that racism, misogyny, colonization, oppression, and exploitation stem from a single source: the great divide operated by Western thought between "human" and "natural," between the cultural and the living.[30] According to Lévi-Strauss, "The exploitation of Man by man [...] appears concretely in History in the form of an exploitation of the colonized by the colonizer; in other words, through the appropriation, for the exploiter's profit, of the extra surplus which [...] the primitive has the full right to dispose of."[31]

Hannah Arendt took this reasoning further by seeing colonialism as the ideological matrix of Nazism, since a regime that establishes racism as the basis of social organization, only granting full human status to a self-designated elite, could only lead to the Shoah.[32] Spanish conquistadors justified their massacres by the principle of the division of beings, considering that conquered peoples were not humans but animals. Colonialism as an ideological source of Nazism? An American anthropologist of the Cree nation, Jack D. Forbes, formulates the analogy more directly by comparing Christopher Columbus to Hitler according to what he calls *wetiko*, a term referring to "a cannibal, or more specifically an evil person or spirit who terrorizes other creatures by means of terrible evil acts, including cannibalism."[33] This compulsion to "consume the life of others" for private purposes in order to profit from them is a disease of the mind that expresses itself through economic

[30] Philippe Descola, *Beyond Nature and Culture*, trans. Janet Lloyd (Chicago: University of Chicago Press, 2013).

[31] Claude Lévi-Strauss, *Structural Anthropology*, vol. 2, trans. Monique Layton (Chicago: University of Chicago Press), 314.

[32] Hannah Arendt, *Imperialism: Part Two of the Origins of Totalitarianism* (Boston: Mariner Books, 1968).

[33] Jack D. Forbes, *Columbus and Other Cannibals: The Wetiko Disease of Exploitation, Imperialism, and Terrorism* (New York: Seven Stories Press, 2008).

exploitation, expropriation, and productivism, spread by the West at the same time as smallpox.

Another symptom: what we now know as the "seventh continent," the huge floating mass of plastic waste adrift in the oceans, is a concrete reflection of the Anthropocene.[34] This "territory," which is estimated to weigh seven million tons, six times larger than France, is the pure product of human activity, namely, of one of the primary characteristics of global economy, that is, the production of *disposable* objects. This drifting continent literally took shape *behind our backs*, owing to our inability to recycle our waste. It is the concrete, palpable representation of a world we refuse to look in the face: the materialized unconscious of the Anthropocene, a return of the repressed. Because this "new world," as translucent as it is uninhabitable, is a (distant, but direct) effect of colonization. As a territory, it is a negative space: in other words, the exact opposite of the New World discovered by Christopher Columbus, which European colonists considered a virgin, uninhabited territory, a "copyright-free image" of sorts. Born of excess product and irresponsible lifestyles, the seventh continent seems like the belated echo, or rather the *counter-image* of the colonial process, which can be considered the historical source of the ecological catastrophe. The result of the appropriation of the world by productivist ideology, the seventh continent is a new world no one will ever try to colonize. Indeed, the colonial process has only changed its nature and objectives: rather than extending in space through military conquest or financial dependencies, it generates vertical segregations within each society.

In one of his last public appearances, Lévi-Strauss raised the alarm: "By acting as though we defended [endangered peoples], but too late to be able to save them, it is rather ourselves that we feel sorry for and would like to protect. Ourselves, that is, a humanity that has become too numerous on a terrestrial space it cannot extend, *and that is consequently reduced to colonizing itself.*"[35] The notion

[34] "The Seventh Continent" was the title of the 16th Istanbul Biennial, which I curated in 2019.

[35] Speech by Claude Lévi-Strauss, quoted by Salvatore d'Onofrio in *Lévi-Strauss face à la catastrophe: Rien n'est joué, nous pouvons tout reprendre* (Milan: Mimésis, 2019), 59 (my emphasis).

of self-colonization echoes the dominant figure of the con-
temporary world: the loop. The closed-circuit system, feed-
ing upon itself and devoid of any *exterior*, thus appears as a
central motif of the Anthropocene. It appears with the "mad
cow disease" crisis in 2001, which alerted the world to the
fact that bovines are fed the meat and bone meal that con-
tained the remains of other bovines, and that fish are fed
with powdered fish. It returns in another guise in 2008 with
the subprime-mortgage crisis, when banks collapsed under
countless Ponzi schemes, credits financed by other credits
ad infinitum, money producing money. A world on a loop,
spaces asphyxiated because they have no openings, activ-
ities that calcify because they spin around on themselves
and for themselves. Obsessed with his or her own reality,
the human being self-segregates and produces loops. We
cannot understand the Capitalocene without underlining
that human activities held responsible for the ongoing ca-
tastrophe are characterized by the absence of any *outside*.
For Félix Guattari, "It is the relationship between subjectivi-
ty and its exteriority—be it social, animal, vegetable or Cos-
mic—that is compromised in this way, in a sort of general
movement of implosion and regressive infantilization."[36]
In other words, to go back to Aby Warburg, we are running
short on cosmos. The convergence line that connected the
human individuals to something outside themselves; the
cosmos that was destroyed by "the telegraph and the tele-
phone" and replaced with state religions—shoddy versions
of the outside, bureaucracies for the afterworld.

 The philosophies of "radical strangeness" known
as speculative realism or object-oriented thought arose
within this context. As Tristan Garcia explains, this general
call to *le grand dehors*, the "great outside," expresses "a
certain weariness of the human subject contemplating his
own omnipotence": human subjectivity seems to have ex-
hausted itself in these cultural, economic, and existential
loops that offer only glimpses of its own deformed reflec-
tion, the image of a species dependent on its own technical
power. As Garcia explains:
"Culture demanded a new outside; this outside manifested
itself by the reappearance in today's aesthetics of Nature
without man, through the figure of the post-apocalypse

[36] Félix Guattari, *The Three Ecologies*
(London: Athlone Press, 2000), 27.

(representing the world as it will be once we are no longer there, once culture has ceased) and by a taste for horror as the representation of the limits of human representation."[37] Here we are confronted with a frightening alternative: either the great outside of an inhuman universe, or the supremacy of human subjectivity, in the nightmare form of self-colonization of the human by the human. In art, postmodernism was the paradigm of an aesthetics with no exteriority, quotational and self-devouring, whose successive hallmarks were its references to the past (of art), then to cultural identity (of artists), both verging at times on a fetish for history. It isn't surprising that the *quest for interlocutors* has been the central motif of contemporary art for the past twenty years—first of all passers-by, neighbors, surrounding communities, for artists belonging to the relational sphere that appeared in the 1990s.[38] Then the past, memory, and the archive became the central themes of the 2000s. And lastly, the great externalization: the whole of the Real (including atoms, things, and machines) takes on the role of a symbolic interlocutor for a new generation of artists who consider animism and totemism as concrete realities, or even ethical principles.

The necessary existence of an outside, the rush for any available cosmos, underscores the coherence of the mental space shaped by the Capitalocene: we have gone from an *extensive* conception of the world to its *intensive* one. In other words, the outside world, just like exploitable resources, has shifted from the faraway to the near, shrinking space-time. You don't need to physically colonize foreign populations since they are already present in metropolises or online; it's no use seeking an outside far away either, since we coexist with billions of invisible creatures. The elsewhere and the bygone have been flattened against the here and now.

[37] Tristan Garcia, *"Weird Realism: Lovecraft and Philosophy* de Graham Harman," *Le réalisme spéculatif*, no. 255 (Winter 2016), https://www.erudit.org/fr/revues/spirale/2016-n255-spirale02442/81114ac.pdf.

[38] See Nicolas Bourriaud, *Relational Aesthetics* (Paris: Les presses du réel, 1998).

AESTHETIC DEGROWTH

The Capitalocene allows us to relocate art within the field of general production, and this in an inventory of available resources. By leading us to see chainages and interactions where we once perceived masses, the Capitalocene broadens our gaze.

After the Second World War, embarking on an essay on economy, Georges Bataille started with ... the sun. "The source and essence of our wealth," he wrote, "is provided by sunlight, which dispenses energy—wealth—without asking for anything in return."[39] We cannot understand capitalism (or communism or any other social system, or even art) without envisioning it as a specific mode of relation to energy: "The very principle of living matter requires that the chemical operations of life, which demand an expenditure of energy, be gainful, productive of surpluses." Between the two poles of luxury and hoarding, art and waste, the symbolic economy that rules the human world duplicates that of the planet. Bataille, again: "The sun shines and our ground is cold [...]. The greediness of particles is immeasurable: they absorb solar energy and the energy of the ground as free elements. The strongest seize the energy left by the weakest. Men harvest available forces: they absorb, use, accumulate resources of every order—solar, animal, vegetal. The strongest seize the labor of the weakest."[40]

This struggle for energy tends toward its conservation or its accumulation, toward survival. By contrast, art belongs, for Bataille, to the "accursed share" of the economy, along with sumptuary expenditures: in short, it is the opposite of the fantasy of endless *growth* that founds the contemporary economy, of the bulimia that now stands for politics. The world of growth—in opposition to the world of art, which says "I am useless"—is above all the world of the *useful*, that is, of all actions undertaken for future benefit. In the eighteenth century, Benjamin Franklin revealed its formula: "He that kills a breeding Sow, destroys all her Offspring to the thousandth Generation. He that murders a Crown, destroys all it might have produc'd, even Scores

[39] Georges Bataille, "La part maudite," in *Oeuvres completes*, bk. 12 (Paris: Gallimard, 1988), 35.

[40] Bataille, 188.

of Pounds."[41] Money, the origin of a huge loop with no out-side, competes with art as a *luxury*; but the luxury Bataille speaks of has nothing to do with perfumes or handbags. The world of luxury, as defined in his economic theory, in-cludes art, rites, sacrifices, animal predation, and eroticism ("a sudden and frantic dilapidation of energy resources"— or, the formula joining the latter two: "the sex act is to time what the tiger is to space"). Bataille notes that for the Aztec civilization, one of the first to have been destroyed by Eu-ropean conquest, "consumption had no lesser place in their thought than production in ours. They were no less eager to *sacrifice* than we are to work."[42] The symbolic destruction of goods, the potlatches of the North American Indians, the human sacrifices made it possible to give back to the world of the sacred that which had become banal through every-day use. Aztec rites aimed to negate any utilitarian relation-ship between man and animals or plants; in other words, the opposite of the fuel consumed by an engine. We do not destroy an animal, a human being, or a plant as things, but "inasmuch as they have become things." This nuance is crucial.

Unlike most non-European societies, Western cap-italism was built on the myth of the exponential growth of energy. But Bataille also analyzes Islam as a religion based on the project of controlling social energy, aiming to avoid its waste and channeling it instead into war, a strategy that would materialize through a colonial expansion that lasted until the fifteenth century with the loss of the south of Spain. Thus, Bataille compares "Muslim puritanism" with the head of a factory inspecting the building, locating the places where energy is dissipated, and finding a solution to this useless waste by blocking as many apertures as pos-sible. The movement that led to the Muslim religion in the seventh century is similar, for Bataille, to "the development of industry through capitalist accumulation: If waste is halt-ed, if development no longer has a formal limit, the afflux of energy dictates growth, and growth multiplies the accumu-lation."[43] In the second half of the seventeenth century, an-other religious movement disrupted the symbolic economy

[41] Benjamin Franklin, "Advice to a Young Tradesman" (July 21, 1748), Founders Online, https://founders.archives.gov/documents/Franklin/01-03-02-0130.

[42] Bataille, "La part maudite," 52. [43] Bataille, 90.

of Europe: the Protestant Reformation, which resulted in the separation of economy from social life, and the independence of economic laws that would henceforth, as Benjamin Franklin explained, function by and for themselves. The Reformation, Bataille wrote, "destroyed the sacred world, the world of nonproductive consumption, and handed the earth over to the men of production."[44] To the sumptuary expense of the past, prescribed by the protocols of magic and art, the capitalist system would oppose war (which has the advantage of increasing territories), luxury (as social segregation), and the exponential extension of the sphere of waste.

The distinctive feature of economic growth is that it seems just as infinite as solar energy. In fact, the "only objective challenge to development," wrote Jean-François Lyotard, is the sun's life expectancy. The ideology of *growth* expresses belief in the exponential accumulation of wealth, turning the future of humanity into a Ponzi scheme. Lyotard pointed out that "development is not drawn by an Idea, such as the emancipation of human reason and freedom. It reproduces by accelerating, and by spreading according to its own internal dynamics."[45] The content of growth is therefore speed itself: social life as vertigo, a tightrope act whose rope would be a series of loops spinning round and round. If we compare the world economy to a human being, imagine an individual who decides to grow, whatever the cost, one or several extra centimeters a year. Yet everyone knows that the *quantitative* growth of human beings stops when they become adult, and that thereafter the point is to grow in *quality*; but the economy of the species apparently decided to contradict the laws of its physiology. What the West calls *growth* is nothing but progress without content.[46] Until the 1980s, artworks were evaluated according to a linear narrative, each artist "going beyond" his or her predecessors in an endless self-referentiality. Even though *buzz* seems to have replaced *innovation* as the superficial

44 Bataille, 122.

45 Jean-François Lyotard, *L'inhumain: Causeries sur le temps* (Paris: Éditions Galilée, 1988), 14.

46 "The Great Acceleration" was the title of my first exhibition dedicated to the Anthropocene for the Taipei Biennial in September 2014.

mode of aesthetic appreciation (an evolution that bears witness to the loss of influence of historical narratives), the notion remains firmly anchored in the history of Western art. This vision of the world and of culture is based on the Latin prefix "pro-," which indicates both the exterior and marching forward. If *progress* means "going forward," the etymology of the verb "to produce" is "to bring forth." What we produce comes out of us and remains exterior to us, set before us. And our age, as it becomes increasingly responsive to ecological thought, questions the quantity and quality of the products laid out before it. Douglas Huebler, one of the most coherent and radical Conceptual artists of the 1960s, simply said: "The world is full of objects, more or less interesting; I do not wish to add any more. I prefer, simply, to state the existence of things in terms of time and place." Decluttering the world, using what already exists, rehabilitating waste, recycling trash, are commonplace figures of contemporary art, often circular. Yuji Agematsu accumulates filaments and fibrils he collects on the street, Thomas Hirschhorn salvages old cardboard boxes and aluminum sheets, and Pascale Marthine Tayou, plastic bags.

I will not insist here on the ethics of recycling in today's art,[47] only point out that it is part of a general movement for which the notion of *production* has become problematic. But to try to describe precisely what artists are doing today we could say that they *conduct* forms as much as they produce them. When an artist brings together organic elements, industrial products, sounds, images drawn from heterogenous sources or written traces in an artwork or exhibition, he or she becomes a shepherd, leading a series of elements toward a unified form. Therefore, art is most often a matter of conduction ("to advance with, accompany") rather than production.[48] In addition, while an artwork obviously contains the intentions, culture, and idiosyncrasies of its author, it also conducts information from multiple outside sources toward us. There is no such thing as a *pure*, purely passive object: every object that exists in the

[47] On the subject, see my preceding book, *The Exform*, trans. Erik Butler (London: Verso, 2016).

[48] Incidentally, in contemporary culinary art, the fermentation of fruit and vegetables is in vogue. It consists precisely in "cooperating" with bacteria, conducting them toward the desired result.

universe stores, processes, and emits information. When an artist assembles materials that come from different levels of reality (cultural as well as natural), he or she becomes a conductor, a shepherd, a conduit. When he or she works with objects or products, the artist does not only espouse our general suspicion as to human production, but also imposes, at the same time, the idea that art is a sample collected from a *milieu*, the witness of an active presence within an ecosystem.

In the fourth century BC, in Athens there lived an immigrant from Sinope, the city located in today's Turkey, which was founded by Greek colonists on the southern coast of the Black Sea. He was a foreign resident, a metic, and had been a slave at one time, despite coming from an affluent family. In the streets of Athens, he survived by supplying what he called "philosophical services" in exchange for alms. Today, Diogenes would be considered a homeless person. But "status is nothing," he said. "Everyone delimits, no matter what it may be, the perimeter of his freedom."[49] Even though the few books he published during his lifetime were lost, we still remember Diogenes's teachings through anecdotes and quotes. Ultimately, his way of life was the true medium of his philosophy, which expressed itself through actions. Diogenes lived not in a "barrel," since the object did not exist in Greece at the time, but in an earthenware jar. The distinction is important, since he belonged to a world of clay, and the small cistern that served as a home for him was made from the dominant material of his urban environment: he even expressed his theory of education by using the metaphor of unbaked clay. His actions were pedagogical performance art: seeing a child drink from his own hands, Diogenes throws away his own cup; he walks a fish in the streets, like the Japanese artist Shimabuku would take an octopus on a walking tour of Tokyo twenty-six centuries later. Diogenes was "Socrates gone mad," said Plato, who had no love for artists. This is because Diogenes's thinking was visual, *in action*: stated through striking, vivid formulas, disseminated throughout the city of Athens, which he saw as his medium of intervention. He invented the concept of cosmopolitanism (and certainly the word itself), proclaiming he was a "citizen of the

[49] Diogenes, in Jean-Manuel Roubineau, *Diogène* (Paris: Presses Universitaires de France, 2020), 99.

world," and he criticized the founding principles of life in the city. Money would be his great subject: by deciding to beg, that is, to exclude himself deliberately from social life, by advocating the abolition of private property and of any distinction between men and women, he was a cynic, from the Greek word *kunikos*, meaning doglike. A dog-philosopher, he wanted humanity to draw its inspiration from the animal world and to end up "taking on the life of dogs." For "the Cynic's vision of the world is based on the idea that a form of original humanity was perverted, mankind having strayed from a state of equilibrium."[50]

In New York on Sunday, February 13, 1983, a man leaned against a wall, wrapped up in his coat, as snow covered the sidewalks. At his feet, a wool rug served as a stall for a street sale: one dollar for a snowball. All perfectly spherical, they were meticulously lined up, the largest horizontally and the smallest, in a decreasing size, in six vertical lines that evoked the spiral movement of cyclones. Only a handful of photographs remain of David Hammons's best-known piece, *Bliz-aard Ball Sale* (1983). Twenty years later, he would make a kind of memorial monument to it, *Untitled (Snowball)*. But the original event was unannounced, no one commented on it at the time, and it would be years before it took on, slowly, a mythical dimension. The artist and his work have always cultivated a halo of mystery: he is known for being unreachable, bad-tempered, invisible. "I'd like to be a myth, to be on the invisible side. The shadows."[51] Since 1990, he has refused every invitation by institutions, preferring to show his work in a shop that sells ethnic craft or in a museum of history in Illinois. Hammons spent over ten years without a phone or a bank account, sleeping here and there, on the margins. After having made markings with his own body in the 1960s, he developed a visual mythology of precarity via forms often associated with African American culture: Afro hairstyles, street installations, boxers, basketball hoops. Made of samples collected from the urban forest, his work seems to emanate from the city's sidewalks, and tells a very different narrative of America. One day, he urinated on a piece by Richard Serra

50 Diogenes, in Roubineau, 103.

51 David Hammons, quoted in Elena Filipovic, *David Hammons: Bliz-aard Ball Sale* (London: Afterall Books, 2017), 15.

(*Pissed Off*, 1980), just like Diogenes snubbed Alexander the Great; another day, he turned the trash on a street in Los Angeles into an ephemeral sculpture. Hammons moved about in a world of expedients and debris just as Diogenes moved about in the clay of Athens; Hammons's environment was both his material and his theater of operations. That's what *Bliz-aard Ball Sale* shows, in an enlightening metaphor of the artistic process: the snow that has just fallen from the sky, covering the street, within easy reach of anyone, changes dimension and status through the magic of being given a shape. And the presence of this object changes behaviors, as Hammond explained: "When you have an object between you and them, people will talk to you. They'll say 'What is that? Is that for sale?' But if you're just standing on a street corner, everyone's an enemy of each other. But an object ... It becomes a conduit to conversation with someone you have never met before."[52]

A critical view of the myth of economic growth, the art of our times builds onto globalized capitalism in the same way painters depended on the biblical narrative during the Renaissance, with the distinction that today's art can just as well vilify capitalism as play into its hands, not always on purpose. Will the age of rising oceans and pandemics produce a new type of artist? If this is the case, I would wager on their *Diogenic* dimension: the artist as the author of critical thought, immersed in his or her milieu, whose actions and traces bear a vision of the world, including in the wavelengths that his or her work forms from emissions drawn from the most various points. Inclusive thinking, emitted by artists located in a milieu, immersed among signs.

[52] Hammons, in Filipovic, 73.

Toward Inclusive Aesthetics

We can predict that in twenty years, the bulimia that drives us to engulf all forms of art past and present to elaborate ours will be increasingly difficult to satisfy. [...] While nothing will have changed on the surface, we will understand, perhaps better than we do today, that a society bears its art like a tree its flowers, as a function of their being rooted in a world which neither one nor the other claims to make entirely its own.
Claude Lévi-Strauss

Two great European artists, Mark Leckey and Pierre Huyghe, address very similar issues in their work. Leckey advocates a relationship with objects that do away with the mediation of language: today, he says, "you can talk about, or rather involve yourself with objects, without continuous recourse to concepts and critique. Not only approaching them as though they are only organized by language, by us. You can try and empathize with them on a whole other level."[1] As for Huyghe, he often shows living creatures—bees, dogs, mollusks, or bacilli—and formulates the hypothesis of "a world without humans." These organisms, by producing forms within the regulated context of his exhibitions, add an unpredictable or accidental dimension to them. By claiming he doesn't "want to exhibit something to someone, but rather the reverse: to exhibit someone to something," Huyghe upends the conventions that bind the artist and the beholder, human consciousness and its *objects*: in other words, art is considered to be an experience, an experience driven by absolute contingency in which the beholder plays the role of an active witness. When Leckey declares he has "a direct and empathetic connection" with objects, a connection that does not go through the mediation of human language, he speaks like Cézanne, Giacometti, or further back in time, the great Chinese painter Shitao, all of whom sought to penetrate the secret structures of the visible by working at deconditioning their eye. To define his research, Huyghe uses a similar expression, saying he is interested in "intensifying the presence of what is." Through other means, Cézanne had a similar ambition to Huyghe: to render as accurately as possible the luminous shock of the manifestation of the visible, the majesty of the world as it presents itself to our mind, whether it is a fruit basket or Mont Sainte-Victoire.

 Leckey's exhibition "The Universal Addressability of Dumb Things" (2013), referred to a concept used in computer science, according to which a network of objects could communicate without the intervention of a sentient agent. The central part of the exhibition was a museum-style, frontal presentation of objects, some on the floor, others on stands or hung on the wall, in a green

[1] Mark Leckey, by Lauren Cornell, "Techno-animism," *Mousse*, no. 37 (February–March 2013), https://www.moussemagazine.it/magazine/lauren-cornell-techno-animism-2013/.

environment. The artifacts, whose egg-like shapes were reminiscent of Yves Tanguy's landscapes, came from various eras and places. While "The Universal Addressability of Dumb Things" explored "techno-animism," it also indicated the persistence of the human, since it displayed a network of prostheses—a body to be rebuilt. As Leckey explains: "Approaching an object as if it has some essential property that the artist then attempts to draw out of it isn't something taught at art school anymore. But now I feel we've entered a strange new sensory realm: the vivid and mortal sensations created by the convincing visual surface texture of HD, the warm regard you feel toward your stamped metal devices, or the aboriginal shudder you get watching ASMR videos on YouTube. Paradoxically cold autistic cyberspace takes us back to an appreciation of sensuality."[2]
Marveling at the presence of the world, valuing the resources provided by our nervous system, Leckey endeavors to approach objects outside of any human mediation to ultimately better connect with them *sensually*. Conversely, in his work, Huyghe tries to remove any apparent trace of personal subjectivity to focus on the exhibition visitor. What might be the common point between these artists? They embody two different premises, but both are part of a groundswell movement of art in the early twenty-first century that shatters the subject-object relationship, and with it, the relationship between the beholder and the artwork. They are both artists of *immersion* in the world.

REVERSE HUMANISM: A CRITIQUE OF "OBJECT-ORIENTED THOUGHT"

> *The text is a historical object, like the trunk of a tree.*
> Michel Foucault

In the field of art, in the name of critiquing anthropocentrism, the subject-object relationship is attacked from all sides today. Since the 1960s, the invisible engine of contemporary thought has been a systematic critique of the concept of the *center*. Ethnocentrism, phallocentrism, anthropocentrism. The current burgeoning of these derogatory terms demonstrates that the a priori rejection of

[2] Leckey

any centrality is the great struggle of our time. The center, as a figure, represents the absolute foil of contemporary thought. But isn't the human subject the supreme center? We have no choice but to hold this notion in general suspicion, as any such claim would be seen as a crime. The real crime of humanity, after all, lies in being a colonial species: since the dawn of time, human populations have invaded and occupied neighboring kingdoms, reducing other forms of life to the rank of slave, ruthlessly exploiting their environment. But contemporary thinkers, instead of trying to redefine the relationship between their conspecifics and other living beings, have ultimately reduced philosophy to a bad conscience constantly ruminating, a simple act of penance, even a fetish device. Isn't this theatrical display of humility, this so-called contrition, merely an extension of the old Western humanism, though it appears today in reverse form? What this reverse anthropocentrism expresses in the guise of a systematic critique of all centrality is, above all, the unconscious will to maintain the existence of this central zone, while filling it with negative values.

For the past ten years, human thought has therefore turned to things, as though it were seeking out a new equilibrium at a time when the species is realizing its disastrous action on the planet. It is within this historical context that a new philosophical constellation has emerged, speculative realism or object-oriented thought, for which human beings and animals, plants, or products should all be treated on an equal footing. Thus, Bruno Latour suggests a "parliament of things," Levi R. Bryant a "democracy of objects." Graham Harman proposes an object-oriented philosophy that attempts to free objects from the shadow of our consciousness, giving them metaphysical autonomy and putting collisions between things on an equal footing with relationships between thinking subjects, so that these two types of relationships can only be distinguished by their degree of complexity—humans only distinguish themselves, according to Harman, by their status as "sensual objects." As for Quentin Meillassoux, he attacks the "anti-realist" worldview according to which nothing exists outside the correlation between subject and object—thought on one side and being on the other? Reality is at the center, he says, and the human being is just one element among many others in the network it constitutes. In *The Democracy of Objects* (2011), Bryant writes: "This essay attempts to think

an object for-itself that isn't an object for the gaze of a sub-
ject, representation, or a cultural discourse. [...] The claim
that all objects equally exist is the claim that no object can
be treated as constructed by another object. [...] In short,
no object such as the subject or culture is the ground of all
others."[3] If being takes precedence over knowledge and
the thing over the consciousness that envisages it, then
the world becomes purely horizontal. No entity can occupy
the center, apart from what could be designated as *reality*.
As for politics, it becomes a general ecology addressing
human and nonhuman agents. But when we consider the
world as a simple *substance*, we are no longer considering
it as a network of relations. Doesn't this lay the ontological
groundwork for the representation of the world as a raw
material to be exploited?

 By extension, what would an exhibition be like if it
were rid of all "correlationism"? The term, coined by Meil-
lassoux, refers to the idea that knowledge of the world is
always the result of a correlation between a subject and an
object, the typical perspective of Western philosophy. Meil-
lassoux raises a fundamental question: How can we grasp
the meaning of a statement on data anterior to any human
presence, that is, prior to the existence of any relationship
between the object and the conscience that reflects it? In
short, how can one think about something that exists com-
pletely outside of human thought? To do so, he develops
the concept of the "arche-fossil," which means a reality that
preceded the existence of any observer.[4] In posing the the-
oretical question of the arche-fossil, Meillassoux does not
seek to formally condemn the subject-object relationship,
but sets philosophy in relation to a metaphysical absolute,
to an *outside*, which can be considered here as a pure con-
tingency, as something that is "capable of existing, whether
we exist or not."[5] Though Meillassoux's theory is fasci-
nating, transposing it as is into the aesthetic discussion
results in shattering the concept of art, because it is based
specifically on and within such correlationism: art is a signal

[3] Levi R. Bryant, *The Democracy of Objects*
(Ann Arbor, MI: Open Humanities Press, 2011), 19.

[4] Quentin Meillassoux, *Après la finitude*
(Paris: Le Seuil, 2006), 26.

[5] Meillassoux, 39.

emitted by an individual or a group of individuals, received (or not) by others. As Roger Caillois reminds us, all existing forms should be distinguished by how they are brought into being: growth, molding, accident, or project.[6] But art as we know it, if it may integrate forms from the three first categories, is always the outcome of a project. We can even go further and point out that, according to Marcel Duchamp's famous saying, "The beholders make the picture," the latter becomes a mere *thing* as soon as no one looks at it. The purpose of all art is to generate consequences: it addresses a public and meaning is found through the human eye— art exists through *repercussion*. As for the relationship between objects, it is a collision between things; they may produce data that can be analyzed by a digital intelligence, but nothing similar to the effects generated by works of art—that is, the Brownian, unpredictable, and fertile movements conveyed by erratic human consciousnesses.

But let's return to the two premises presented by Huyghe and Leckey. The latter speculates on the existence of a network of interconnected objects with a corresponding (Cézannean) project to observe reality, that is, to seek out the *secret* existence of things, the structure of their relationships. Huyghe sets up living apparatuses left to chance, of which the beholder-witness, immersed in a situation that exceeds any individual consciousness, is only one facet. (*Untilled*, presented at dOCUMENTA (13) in Kassel, is a perfect example of this through its complex combination of dynamic processes, from compost to a bee-hive and a dog with a colored paw, in the open-air space of a park). Their common point is that both artists challenge the subject-object relationship that has structured Western societies for centuries. The *witness* Huyghe speaks of is not there to account for an object, but to be exposed to events, phenomena. Speculative realism offers a very different model, that of an onward march of *horizontalization*, in which the elements that compose reality are set up in a network under the aegis of the object: this is Levy Bryant's "flat ontology," or the "great outside" conceptualized

[6] Roger Caillois, "Cohérences aventureuses," in *Oeuvres* (Paris: Gallimard, 2008), 816. Michel de Montaigne reminds us that Plato distinguished three: nature, "fortune" (chance), or art. See Montaigne, "Des cannibales," in *Les essais* (Paris: Éditions Arléa, 1992), 155. To these, Caillois adds mechanical reproduction.

by Meillassoux. But art, since it exists solely as an encounter, is quickly stifled in this type of landscape. Indeed, if we could identify its mathematical essence it would be the omega function, defined as the infinity of prime numbers + 1. It is this "+1" that constitutes the artwork as an experience: that is, the encounter with a *singularity*, with an object (in the broad sense of the term: a thing, word, gesture, sound, drawing, etc.), within the framework of an event that rekindles the infinite conversation known as art. Art could therefore be defined as the fundamental locus of the signifier (everything in it produces sense), since such is the condition of its existence, and if truth be told, the only capacity in which it belongs to reality.

According to Harman, one of the main theorists of object-oriented thought, "the primacy of relations over things is no longer a liberating idea (since it reduces things to their pragmatic impact on humans and on each other)."[7] However, it seems difficult to maintain the existence of the notion of art beyond the sphere of these "relations": the sole vector of artistic activity being interhuman relations, the "primacy of relations over things," represents less of an ideological choice than a pragmatic necessity. To pose the problem differently: How can a thing removed from the field of "relations," like a fish from its aquarium, constitute as a work of art? It is the human gaze that confirms its belonging to the artistic domain, which is not a physical or metaphysical category, but simply a particular mode of the relations we maintain with things and beings. It is only because a human being *uses* it in a certain way, an *aesthetic* use, that the status of a thing is modified. Otherwise, it would only be an artifact among others, a sign among other signs (buried in a forest, a painting by Velasquez no longer belongs to the field of art). Since art is not a category of objects, but a specific regime of the human gaze, its existence is inseparable from the presence of the "active witness" Huyghe speaks of. It only exists because the human being uses it, and invents, classifies, conserves, and values a class of objects that correspond to this use. Any other definition of artistic practice belongs, de facto, to idealist thinking. There is no art if it does not address someone, in the singular or the plural, and an artwork only exists in the

presence of a witness, otherwise it turns into an arche-fos-sil. What is an uninhabited house, if not a heap of materials?

For the record, object-oriented thought is far from being the first movement to contest the principles that un-derpin classic humanism: they were already being disman-tled as early as the 1960s. It is hard to find anything radi-cally new in flat ontology for a reader of Alain Robbe-Grillet (whose first novels featured a narrator devoid of interiority describing a world of objects), or even for anyone familiar with the Minimalist and Conceptual art of the same period. The notion of subjectivity itself has gone beyond the frame-work of humanism. For instance, Félix Guattari relocates it within an *ecosophy* that envisions the environment, social relations, and subjectivity as a whole. For Guattari, "Subjec-tivity is not only human. It is also mechanic. For instance, the subjectivity produced by mass-media, computers, lan-guage systems. [...] Subjectivity is the raw material of the human species, what makes individual life, collective life and life full stop, possible."[8] Thus, Guattari places the urban world, natural sites, and interhuman relations on the same level: "Nature cannot be separated from culture; in order to comprehend the interactions between ecosystems, the mechanosphere and the social and individual Universes of reference, we must learn to think 'transversally.'"[9] For Guattarian ecosophy, the proliferation of mutant algae, television programs, and the gentrification of neighbor-hoods are part of the same problem: pollution. And if we follow Guattari's line of reasoning, the current domination of the object in the contemporary imaginary might well consti-tute the ultimate consequence of the "void in subjectivity" whose devastating effects he perceived, a void created by an age that "exacerbates the production of material and immaterial goods to the detriment of the consistency of individual and collective existential territories."[10] Therefore, an ecological problem. Desertification not only affects land-scapes, but also human brains.

The theoretical model of the subject/object that

[8] Félix Guattari, *Qu'est-ce que l'écosophie?* (Paris: Éditions Lignes-IMEC, 2013), 332.

[9] Félix Guattari, *Les trois ecologies* (Paris: Éditions Galilée, 1989), 34.

[10] Guattari, 39.

rules Western thought was also deeply disrupted by struc-
turalism. In his book *What Is an Author?* (1969), Michel Fou-
cault already established a distinction between the classic
notion of the subject and the "field of subjectivation," that
is, a composite of heterogenous elements, human or non-
human. The famous passage on "the end of man" that con-
cludes Foucault's *The Order of Things* (1966) still resonates,
and we could even argue that it anticipates the philosoph-
ical program of our era: "As the archaeology of our thought
easily shows, man is an invention of recent date. And
perhaps one nearing its end. If those arrangements were
to disappear as they appeared, [...] then one can certainly
wager that man would be erased, like a face drawn in the
sand at the edge of the sea."[11] What can those disappear-
ing "arrangements" be that would allow the ocean of things
to erase the human face? For Foucault, and for structuralist
thought in general, mental configurations are what gener-
ate discourses, institutions, and ways of life shape a situa-
tion in history. What stands out as the singularity of today's
speculative realism is not the erasure of the human being
in favor of things (or of the structures that determine him
or her, as in structuralism), but the obliteration of language,
removed from the field of thought. By evacuating thought,
speculative realism confronts, in a binarism that is just as
arbitrary as the nature/culture dyad, the human being with
a mute "outside." This can be explained by the fact that
the protagonists of this philosophical movement tend to
consider language as a purely human *object*. But if lan-
guage is indeed an object among so many others, it is not
a substance that is added on top of the "real" world: human
languages enable us to collect, decode, and overdetermine
(which does not mean dominate) the signs emitted on the
earth. In a way, language has to do with bacteriology: it
transmits, splices, and coagulates, playing in physical real-
ity a role analogous to that of bacteria in a human body. As
for art, it is a human *delegation* to nonhuman realms. Thus,
in the final analysis, art belongs to the sphere of diplomacy.
 This "turn toward objects" was widely commented

[11] Michel Foucault, *Les mots et les choses:
Une archéologie des sciences humaines*
(Paris: Gallimard, 1966), 398.

on in the world of contemporary art. The context of its appearance, in the mid-2000s, is of course the Capitalocene. If a plant, a seed, or even a gesture (as we see today in the digital industry) are liable to be patented and marketed by a company, conceiving the world as a series of objects falls in line with global capitalism. Bearing this in mind, Bryant's formula ("There is only one type of beings: objects.")[12] takes on an alarming resonance. It allows us to interpret object-oriented thought as an effect of the dominant ideology, which urges us to conceive the world as a huge display of substances, interconnected of course, but that only exist within an entirely reified landscape. At an earlier stage of the capitalist system, when Marx discovered the concept of the *commodity fetish*, he described the worker as *alienated*, because he or she was no longer connected with the living product of his or her labor. This alienation, inseparable from the accumulation of capital, now extends to the biosphere: because a company can appropriate a forest, because fish or fruit are products and natural resources are pure objects of speculation, capitalism now encompasses all of the environment. Or more specifically, the whole of the living takes on the form of capital. "Object-oriented democracy," to quote Bruno Latour, can therefore be turned inside out like a glove and reveal itself to be the law of market forces itself, *naturalized* at last. In a world where the living is only one *moment* of the commodity, mankind contaminates it with its own alienation. The term, today, must be understood in its literal sense: *to make other, to make alien*.

Now let's go back to Mark Leckey's words: "You can talk about, or rather involve yourself with objects, without continuous recourse to concepts and critique. Not only approaching them as though they are only organized by language, by us. You can try and empathize with them on a whole other level." Here, the artist agrees with some of the intuitions of structuralism, except that he assimilates language to "we," human beings, while conversely, structural analysis starts from the principle that "it speaks," full stop. But there needs to be someone who listens. We know that cultural studies as an academic field was born at the University of Birmingham, but we seem to have forgotten that it would have never existed without the structuralist revo-

[12] Bryant, *Democracy of Objects*, 20.

lution.[13] And if a mainstream movie, a pop singer, a recipe, or a nightclub can be potential philosophical objects today, it is thanks to the instruments we have inherited from it. Structuralist thought let us broaden our knowledge of the world in two directions: the verticality of social classes and their practices, by studying objects that were then considered "insignificant" by academia; and the horizontality of environments and territories, turning anthropology into the study of the articulation between nature and culture, which includes all biotopes *alongside* human beings. As it happens, this dissemination of sense in all directions, this pollination of the nonhuman world, has been inseparable from the evolution of art since the second half of the twentieth century.

If a single formula could sum up structuralism, it would therefore be this: *it speaks*. From the works of the linguists of the Vienna Circle to the theoretical constructions of Jacques Lacan, or Foucault during his first period, structuralist thought shows, in very diverse fields, that the human individual does not have a monopoly over language, or even speech. The object of structuralism is not the human species but systems—the set of conscious or unconscious relations it takes part in. Since these structures overdetermine all human production, anthropology, philosophy, or psychoanalysis, they can take as an object for study the apparatuses in which subjects move about: not only their language but all the elements that "speak" in a society or a milieu, from institutions to consumer products, by way of the unconscious or cuisine. It is in this sense that Patrice Maniglier writes that Claude Lévi-Strauss's structuralism "allows us to understand how philosophy can feed on a film for teenagers like *The Matrix*: not by offering up its deepest meaning, but by accepting that a Hollywood movie, like myth according to Lévi-Strauss, does not have a fixed meaning, and that it produces meaning by combining aspects of culture that are very distant from each other, religion and comics, cinema and metaphysics."[14] Structuralism is the appearance, within theory, of a rhetorical figure, prosopopoeia: the author is a ventriloquist who makes all sorts of objects speak and extracts them

[13] See Stuart Hall, whose writings often make references to Louis Althusser. On the relationship between Althusser and critical studies, see Bourriaud, *The Exform*.

from the discourse that constitutes them. "I believe the ultimate goal of the human sciences to be not to constitute, but to dissolve man," Lévi-Strauss wrote.[15] Foucault, while positing "the death of man" as the ultimate horizon of human sciences (or rather: the death certificate of a certain conception of the human being), drew similar conclusions in his history of the institutionalization of madness. As for Lacan, he considered the unconscious not as a little family theater but as linguistic machinery that goes beyond the individual—for we are born in language like a fish in water. We know that structuralist thought was an anti-humanism. The concept of "theoretical antihumanism" forged by Louis Althusser invites us to think the world from a broader field of intelligibility, to change our optical instrument. When Althusser defined history as a *process without a subject*, he did not mean that human beings do not take part in it, but that it is a random, chaotic movement that no isolated agent can pretend to drive—and the Anthropocene, just like COVID-19, reminds us of that.

The artists who put human subjectivity into perspective today are evidence of a contemporary *resumption* of this antihumanism, which is therefore not limited to *object orientation*. If we can say that today's art is antihumanist, it isn't in the narrow sense of hostility toward the human being. The term should rather be understood in the sense that Althusser gave to it, which is summed up by a simple proposition: the concept of man, the reason of his preeminence over all other regimes of existence, was only an avatar of the idea of God—which allows us to use the masculine form here. The Cartesian subject, the ego of classical Western philosophy (the *res cogitans*) can only exist if it is indexed to God. What we call "humanism" is therefore indissolubly linked to the division, religious in origin, between nature and culture. Certain artists of the 1960s were the contemporaries of this radical change in perspective. Conceptual artists in particular, by bringing to light the linguistic nature of the artwork, then by insisting on defining it as the

[14] Patrice Maniglier, "Ce qu'ils ont appris de Lévi-Strauss," November 3, 2009, *Le Monde*, http://www.lemonde.fr/planete/article/2009/11/03/ce-qu-ils-ont-appris-de-levi-strauss-pascal-maniglier_1122719_3244.html.

[15] Lévi-Strauss, *The Savage Mind*, 247.

product of its cultural and institutional context, and finally by their tendency to erase the figure of the artist-creator in favor of collective, anonymous processes—for instance, when Douglas Huebler let the American postal service shape his work by carrying it, duly stamped, from one city to another. But we could also quote Land art, since Robert Smithson or Richard Long gave natural elements a similar role in the composition of their works, whose final form involved all of nature: the living beings that literally came to *inhabit* their projects. The relations between Conceptual art, Minimal art, and structuralism are even more obvious (and determining) in the light of Lévi-Strauss's condemnation of the classic opposition between form and content: "For structuralism, this opposition does not exist. Structuralism does not treat one as abstract and the other as concrete. There is not something abstract on one side and something concrete on the other. Form and content are of the same nature, amenable to the same type of analysis."[16]

Structural anthropology focuses on signs; it is a *semiological* discipline. The "sense" of an utterance or a phenomenon thus results from the ordered combination of elements that, taken in isolation, may seem devoid of meaning. Sense has no locus, or a single origin, certainly not the human brain. It was this displacement of the locus of sense beyond the sphere of supposedly specialized activities (art, science, language, etc.) that raised such an outcry among humanist philosophers in the 1960s. What is certain is that structuralism contributed to dissolve the *humanist program* that consisted in becoming "master and possessor of nature," the great colonialist segregation based on the opposition between the *cultural* and the *natural*. Lévi-Strauss, Foucault, and Althusser, among others, opened fire on anthropocentrism, whose standard of measurement was the Cartesian subject and which used rationality to justify the productivist exploitation of the planet.

Let's not forget that our world was not always populated by objects, that we have gradually transformed its living forms into figures and algorithms, materials to be carved up, products to be sold. This *devitalisation* is what connects capitalism, patriarchy, slavery, social segregation, the exploitation of lands, subsoils, and animals—all are

[16] Claude Lévi-Strauss, *Anthropologie structurale*, vol. 2 (Paris: Plon, 1958), 158.

based on a gradual distinction between the status of sub-
ject and object. Their organized denigration was part of a
multifaceted expropriation project: in Europe, in the Middle
Ages, common lands were turned into private property—a
phenomenon called *enclosure*, which redefined the natural
world as a *resource to be exploited* rather than a common
good, a source of nourishment. At the same time, the no-
tion of common good was shifted to women through the
domestic appropriation of their labor force and the patriar-
chal control of their bodies, leading to the criminalization
of their reproductive rights.[17] Losing their status as fully
fledged subjects and socially marginalized, women endured
the same fate as nature in the sixteenth century: they were
assigned to the realm of objects, materials, and resources
to be managed and exploited. Colonial conquests furthered
this policy in the name of a rhetoric of "progress" and "civ-
ilization" that considered these territories and their inhab-
itants as other raw materials to refine. In other words, the
place where the line is drawn between subject and object is
not insignificant.

ART AND SUBJECTHOOD

The place of the human being in modern art is not self-evi-
dent. In his text "Art and Objecthood" (1967), Michael Fried
argued against Minimal art, which was gaining momentum
at the time, by denouncing its "theatricality" and its an-
thropomorphism.[18] Taking to task the work of Donald Judd,
Tony Smith, or Robert Morris, which he called "literalist art,"
Fried even goes so far as to speak of a "war" whose stake
would be no less than "the survival of the arts": "Theatre
and theatricality are at war today, not simply with modern-
ist painting (or modernist painting and sculpture), but with
art."[19] Minimal art is "theatrical," Fried claimed, because
"it is concerned with the actual circumstances in which

[17] On the establishment of these relations of domi-
nance and exploitation of women during the capitalist
transition of Europe, see Silvia Federici, *Caliban and
the Witch: Women, the Body and Primitive Accumula-
tion* (New York: Autonomedia, 2004).

[18] Michael Fried, "Art and Objecthood," *Artforum*,
Summer 1967, 12–23.

[19] Fried, 12.

the beholder encounters literalist work."[20] Indeed, it takes
into account the beholder and his or her body as it moves
through space, as well as the actual time of the perception
of a work. According to Morris, one of the artists criticized
by Fried, Minimalist work "takes relationships out of the
work and makes them a function of space, light, and the
viewer's field of vision. The object is but one of the terms
in the newer esthetic."[21] Unlike the modernist art defended
by Fried, an art that "has come to find it imperative that it
defeat or suspend its own objecthood," that is, to subtly
deny its condition as an object by emphasizing form and
asserting itself in an "instantaneousness" meant to abolish
experienced time, the minimalist work of art is "an object
in a *situation* [...] that, virtually by definition, *includes the
beholder*."[22] Too close to real life, too far from the sublime
through which the modernist artwork transcends its status
as an object, the Minimalist artwork is condemned for its
undecidable appearance, "neither painting nor sculpture."
Fried saw them as no more than "specific objects" (a term
coined by Judd), or worse still as "substitutes for people,"
since another Minimalist artist, Tony Smith, insisted on the
fact that his works were neither moveable objects nor mon-
uments. At any rate, Fried reduced them to their "object-
hood," to a presence that belongs, according to him, to the
theatrical register: a factor of "corruption" and "perversion"
for art. Praising the absolute autonomy of the different ar-
tistic disciplines, he explained that "quality" and "value" can
only be found within a medium identified as such, and that
true art must exclusively explore the intrinsic properties of
this medium. The significance of the accusation of "theatri-
cality" directed at Minimal art is easier to understand when
Fried extended it to Robert Rauschenberg and John Cage:
"What lies *between* the arts," he concluded, "is theater."[23]

 The vision of art contained in "Art and Objecthood"

[20] Fried, 15.

[21] Robert Morris, quoted in Fried, 15.

[22] Fried, 15 (emphasis added).

[23] Fried, 21.

[24] Harold Rosenberg, "Defining Art," in *Minimal Art:
A Critical Anthology*, ed. Gregory Battcock
(New York: E. P. Dutton, 1968), 304.

manages the feat of denying both human and object, to
the benefit of the work of art, which is considered as a
timeless absolute. More surprisingly still, the existence of
complex relations between a person and a thing is turned
into a criterion for artistic inauthenticity. Indeed, according
to Fried, the subject-object relationship should only exist in
art in a "continuous and entire presentness," definitely not
with real bodies in concrete social contexts. What seems
to get in the way in his view, what appears superfluous and
awkward in art, is ultimately human presence. Minimal art
is excoriated because it involves the body of the beholder
and his or her position in space, because it is underhand-
edly anthropomorphic, because it offers *situations* involving
objects collected in a room, and, lastly, because it includes
duration in its protocol. The declared enemy is theater, and
we understand why: for Fried nothing is less acceptable
than relations between bodies, objects, and language un-
folding within a specific space and time. In other words,
everything that exists *between* (between the beholder
and the work, painting, and sculpture, etc.) is presented as
disturbing, or even heretical. I wouldn't insist so much on
this text, emblematic as it is, though based on a modernist
aesthetic whose idealism now seems outdated, if Fried's
arguments had not insidiously irrigated contemporary dis-
cussion and anchored a simple idea in people's minds: that
human presence in an artistic protocol is abnormal, gim-
micky, off-topic.

 I would be tempted to reverse the terms of the
problem. Instead of criticizing the objecthood that, para-
doxically, highlights the way in which Minimalist artists have
taken the beholder into account, why not examine how the
artists of the early twenty-first century introduced *subjec-
tivity* within forms—that is, the qualities one attributes to
a subject. The oddness of Fried's text comes from the fact
that the aesthetic debate at the time insisted on the cold
and impersonal character of Minimal and Conceptual art.
Thus, Harold Rosenberg, in a text written the same year,
"Defining Art," sees Minimal art as a "deliberately dehuman-
ized aestheticism," an opinion bolstered by a quote from
the artist Tadaaki Kuwayama: "Ideas, thoughts, philosophy,
reasons, meanings, even the humanity of the artist do not
enter into my work at all. There is only the art itself. That is
all."[24] Not enough humanity, or too much humanity:
When the subject-object relationship is overrated, don't we

end up confining art to this binary formula? When Pierre Huyghe defines the exhibition as a space where the point is "to exhibit someone to something," he clearly indicates that the traditional categories of activity and passivity no longer have any meaning, since the active agent is not necessarily a human individual, and "objects" are not always on the side we think.

We perceive this evolution toward the subject in artists like Laure Prouvost or Mika Rottenberg, both of whom insert film sequences within elaborate environments, establishing a connection between things and images from the outset. In Rottenberg's filmic installations, which show absurdist assembly lines where humans and things exchange their properties, when they are not totally indistinguishable, the individual is an accessory in a mechanism that controls her totally, a quasi-monstrous form ground up in abstruse circuits. "I work," she explains, "with women who use their bodies as 'means of production'—they are athletes, bodybuilders and wrestlers. [...] My work reifies them: I literally turn them into objects."[25] At the opposite end of Rottenberg's clinical, acid visual worlds, but also among the masterpieces of the art of the past thirty years, certain photographs by Gabriel Orozco reproduce this entanglement between humans and things: on the surface of commonplace or wretched objects, we glimpse the trace of a gesture, an imprint, the condensation of a breath, clues to a dissolution of the human being within a universe where he or she is ubiquitous but disseminated among things. In the art of the twenty-first century, human beings seem connected to objects, bogged down in matter, or caught up in huge assembly lines. A common quality then appears that is the exact opposite of Fried's objecthood—what we could call a "subjecthood" inherent to things as well as living beings, endowing with the status of "person" the elements arranged by an artist within the formal network of a piece. *It speaks.*

A scientific object and imaginary projection, the Anthropocene drives today's artists to reconsider their position within the chain of the living, ranging from geological magma to a Q-tip. This position determines their

[25] Mika Rottenberg, quoted in Eleanor Heartney, "Mika Rottenberg Putting the Body to Work," *artpress*, no. 377, April 2011, 49.

production. In the first place, it is the notion of subjectivity
that shifts, not just because of this awareness, but also
because of the preeminent place of machines. Instead of a
relation between a human subject and objects, we see the
creation of relations between subjects of different natures
treated on an equal footing. Therefore, it isn't by chance
that the world of art embraced the notion of *animism* in
the 2010s. An exhibition of the same name drew from
Félix Guattari's theories to treat the subject of animation
in political or postcolonial terms.[26] But what is the act of
endowing an object with a soul, if not another coloniza-
tion process? Granted, you can endow a thing with human
properties, make an animal speak your language, or treat
your smartphone as a friend, annex it to your system, and
in so doing, forcibly bind it to humanity. Since Philip K. Dick,
science fiction has never ceased exploring the uncertain
boundaries between man and machine, artificial and natural
intelligence. What emerges brutally in the art of the early
twenty-first century is the political perception of the circuit
of the living: things and beings are presented as energy
convectors, catalyzers, or messengers. And while animism
merely lends a soul to inanimate objects, contemporary art
reaches out to the living in every direction, explores every
level of the biosphere. The artists of our times thus build
poetic machines showing robotized or vegetalized humans,
connected plants, animals at work. Constantly hovering
between reification (the transformation of the living into a
thing) and prosopopoeia, contemporary art foresaw specu-
lative realism's flat ontology, but without reducing the whole
of the living to the sole category of the object.

 What then becomes of the artist's ego in the men-
tal landscape of the Capitalocene? Artworks include auto-
biographical or intimate elements, but put into perspective
by sociological or historical elements, machinic or organic
processes. Let's take the example of Pierre Huyghe again:
the autobiographical dimension of his work is undeniable,
but it emerges through social objects (e.g., a song by Kate
Bush used as background music, or the reproduction of a
modernist sculpture in the high school he went to),
as is often the case during a psychoanalytical cure. In the

[26] "Animism," curated by Anselm Franke, first shown
at Museum of Contemporary Art Antwerp (M HKA)
and Extra City, Antwerp, 2010.

work of recollection, signs make their way through layers
of screen memories, in a jumble of heterogenous images.
In our world, having turned into a gigantic *social network*
oriented toward products and their commerce, our intima-
cy is lost in the labyrinth, increasingly fragmented by, and
mediated through, objects or events. Intimacy becomes
even more problematic when it is subjected to the injunc-
tion of *exhibiting* itself on social media. And if the form of
the archive is so popular today with artists, it is because it
provides an organizational model for memory, an objective
system for intimacy in the world of algorithms. In this maze,
our memories take on the form of traces left on networks,
like the tracks of an animal in the forest. Therefore, today's
art is no longer the space where the artist expresses the
content of his or her ego, personality, or visions. Dismissing
psychology, the artists of the twenty-first century prefer
to "intensify the presence of what is" or to "empathize with
things," like Huyghe and Leckey.

In Eduardo Kohn's book *How Forests Think* (2013),
based on four years of fieldwork among the Runa of Equa-
dor's Upper Amazon, he shifts the object of anthropology
toward a similar direction: it can no longer be restricted
to the human world, since *anthropos* (the Greek word for
"human") is now a choral subject, multiple, constituted as
a network that goes beyond the species. The Amazon in-
spires a theory of the subject, since it forms a network of
waves, a *semiosis*—that is, a milieu that produces signs
and meanings. This semiosis is the swarm of signals emit-
ted by the biosphere. The forest is populated with multiple
individuals, *selves*: in other words, with subjects. "The
selves, human or nonhuman, simple or complex, are relays
in a semiotic process. They are the product of semiosis,
as well as the starting point of a new interpretation of the
sign, whose product will be a future self."[27] The notion
of the self, which includes nonhuman subjects, helps us
understand the general process of the emission of signs:
unlike art, which is the product of a deliberate intent and a
project, the signs emitted by selves (nonhuman subjects)
are transitive, mere moments within a chain much greater
than the individuals that compose it. "Semiosis is the name

[27] Eduardo Kohn, *How Forests Think: Toward an
Anthropology beyond the Human*
(Berkeley: University of California Press, 2013), 34.

for this living sign process, through which one thought gives rise to another, which in turn gives rise to another, and so on, into the potential future."[28] As Kohn asserts, the human subject harbors several selves, so that the difference between nature and culture does not oppose different classes of beings, human against others, but runs through each of them. This intuition coincides with that of his colleague Eduardo Viveiros de Castro, who embraces the "perspectivist" thought of the Amazonians. According to him, "Perspectivism asserts an intensive difference which brings the human/nonhuman difference *to the interior of each being*."[29] The term "human" is used by the peoples of the Amazon to designate a subject endowed with a point of view, whatever the subject may be, rather than a species in particular: "All beings in the cosmos see themselves as human, and see what we ourselves call human as non-humans."[30] Indeed, in most American myths, animals are former humans: human substance is not fixed, and neither is nature. In an essay on the art of the Amazonian peoples, Jean-Marie Le Clézio wrote: "There is nothing in the universe that is not natural. Cities and their landscapes are as natural as deserts, forests, plains, seas. [...] When they created cities, when they invented concrete, tar and glass, men invented a new jungle—but have not yet become its inhabitants." Conversely, the Caduveo or Yanomami live fully within their milieu: "Their world is not different from ours," Le Clézio continues, "they simply inhabit it, while we are still in exile."[31] Westerners have invented a jungle without an *outside*, without a cosmos (in the sense that Warburg gave to the word): they have locked themselves up in their own world of signs, deprived of any dialogue with other *selves*.

Even though it is signed by an individual, an artwork can call forth other voices, incorporate multiple agents,

[28] Kohn, 33.

[29] Eduardo Viveiros de Castro, *Cannibal Metaphysics*, trans. Peter Skafish (Minneapolis, MN: Univocal Publishing, 2014), 36.

[30] Eduardo Viveiros de Castro, *Politique des multiplicités* (Paris: Éditions Dehors, 2019), 109.

[31] Jean-Marie Gustave Le Clézio, *Haï* (Paris: Flammarion, 1971), 36.

encompass many points of view. It could be described as choral: it forms a "field of subjectivation," to repeat the phrase coined by Foucault in his *History of Sexuality*. The subject is not necessarily an autonomous individual but can arise from the encounter between a form (personal) and a force (historical or ideological). In a tribute to Foucault, Gilles Deleuze delivers his interpretation of the notion: "Subjectivation doesn't even have anything to do with a 'person': it's a particular or collective individuation characteristic of an event (a time of day, a river, a wind, a life ...)."[32] Therefore, individuation is not necessarily exclusive to the human subject. Forty years later, anthropology has followed in the footsteps of Foucault and Deleuze by drawing from Amazonian thought to broaden the notion of the subject, defined as "a relay in a semiotic process." Every being with a point of view is a *self*. In the nineteenth century, the German biologist Jakob von Uexküll called the sensorial environment specific to a species or an individual *Umwelt*. It is the "own world" of an animal, determined by what it can perceive and do based on its mental and physical characteristics in a given environment. According to Viveiros de Castro, "All beings see ('represent') the world in the *same* way—what changes is the *world* that they see."[33] The difference between subjects is first and foremost the specificity of their organism, what they are capable of seeing and feeling. Each one forms an *idiosyncrasy*, a singular and unique physical and nervous disposition. And if the quality of the subject was long restricted to a certain kind of human being, before being granted to the human species in general, it is because of the specific xenophobia that consists in denying any being different from oneself the ability to perceive, since he or she perceives differently. Being a subject is *framing* the world in a certain way. All segregation arises from the refusal of the other's framing; its purpose is to erase his or her point of view—like in a film where the camera, while pretending to be *objective*, admits no *reverse angle* in the construction of a shot. "Framing is the sole place of the subject, or if you will,

[32] Gilles Deleuze, *Pourparlers, 1972–1990*
(Paris: Éditions de Minuit, 1990), 119.

[33] Eduardo Viveiros de Castro, *The Relative Native: Essays on Indigenous Conceptual Worlds*
(London: Hau Books, 2015), 251.

of the 'author,'" Alain Borer writes about Jacques Villeg-lé's practice of ripped posters. "Man can only frame. Man cannot not frame. Why? Because he is inside the 'real.'"[34] In short, the world can only be perceived as an *object* from the outside, observed by an omniscient God, or what serves as such. Excluding this divine exception, we are all immersed in the real, and we can do nothing else but to frame it. The exceptional regime of this framing, its apex, is art.

Eduardo Kohn describes the human subject, as seen in the Amazon, as populated by multiple selves. Pamela Rosenkranz reprises the idea literally, from a sci-entific standpoint: "New research hints that certain viruses may actually be keeping us healthy, similar to the microbi-otic constellation of bacteria that is so crucial for our im-mune system—think probiotics. New art would be coming into the place of art history as a challenge to the immune system of the discourse. That is how, generation after generation, art history is continuing to alter perception."[35] For the exhibition she produced in Zurich in 2014, "My Sex-uality," Rosenkranz covered the entire space of the gallery with a plastic sheath to make it look like a laboratory. After taking Viagra tablets, she locked herself in the gallery to paint with her bare hands, directly on the floor, a series of paintings on aluminum, *Sexual Power (Viagra painting) 1–11*. Here, the title of the exhibition acts as an antiphrasis: where we would expect an intimate confession, Rosenkranz insists on the biological and chemical determinisms of de-sire and their entanglement with cultural elements. For her there is nothing *natural* about sex, let alone art. Our skin, our love life, or our social behavior are many lines entangled in a huge biochemical network, and art is the outcome of a lengthy physiological adaptation of our species. By paint-ing under the influence of a pill, Pamela Rosenkranz insists on the composite character of the two libidinal activities (i.e., between nature and culture), while underlining their common point: swimming, running, putting on makeup, or making love are all apparatuses of inscription. The subject/object group that speaks in Rosenkranz's exhibition is a

[34] Alain Borer, *Villeglé l'anarchiviste* (Paris: Gallimard, 1990), 193.

[35] Pamela Rosenkranz, interview with the author, January 2015.

chemical-artistic alloy hooked up to the history of female sexuality. She states: "We tend to see sexuality as one of the main markers of our individuality—it helps define us—but not only does our own biological system react to sexual attractions in ways that we can't control, but there are also parasites that can neurologically influence, or possibly even direct, our sense of attraction."[36]

We can now see that the 1990s were the starting point of a more general evolution: in shifting from *I* to *we*, contemporary art began to be invested in the sphere of human interactions. A new generation of artists showed subject-groups, collective subjects integrating the point of view of others—interlocutors, communities, neighbors, or populations.[37] What we are witnessing today is the second stage of this development: the appearance in artistic practices of a series of more complex locutors (or interlocutors) that could be qualified as *subject-object-groups*. Among these, animals, natural objects, products of human industry, machines. In the case of the subject-object-group, the artist is never the sole locutor: just as a computer produces code, each organism follows its own logic, like the crustaceans, flies, and bees that Pierre Huyghe integrates in his exhibitions, Carsten Höller's birds, Tomás Saraceno's spiders, or the ants Hu Xiaoyuan lets run on paper. As for products, they are caught up in a generalized ventriloquism. Most often, what speaks through them is the contemporary *master-signifier*: the capital. Here, the grammar of art is drawn into a *trans* logic (from *he* to *she*, from *it* to *they*) and the artist positions him- or herself as the instigator of a space-time where he or she is just one voice among others in a formal polyphony, a concerto confronting the artist and *something else*. The general empathy Mark Leckey speaks of, or the intensification processes organized by Huyghe, can thus be read through the frame of a grammar of *coactivity*, where things and people, human and nonhumans, are intertwined within a broadened relational sphere. In this, art echoes contemporary scientific representations that describe a hologram-world where there is no material difference between the atoms that compose us, a tree,

[36] Quoted in Aoife Rosenmeyer, "In the Studio: Pamela Rosenkranz," *Art in America*, January 2014.

[37] I will not expand here on this subject. Please see my book *Relational Aesthetics*.

or a fish. The artist practices a vehicular language that prides itself on translating the language of the Other, on adopting *exogenous* modes of framing. The urge to translate may well be the most significant aesthetic event of the first two decades of this century: a synthesis between individual expression and signs emitted by the world, from *I* to *it*, after integrating *we* in the 1990s. For many artists who appeared in the 2000s, natural or biological elements, the world of technology or the remains of the past coexist on the same plane: they are no longer perceived as contradictory. The artist's subjectivity, which manifests itself primarily via formal features (what was once called "style"), a global perspective, and a specific *address* (who is addressed?) readily mixes with logics other than individual expression. Postmodernism, which could retroactively be defined as the historical moment when the artist expressed him- or herself as a sociopolitical sample, draws to a close with this choral art that distributes space-times of speech within the immense concert of signs. The artist-subject, instead of dwelling on his or her own subjectivity, is pervaded by processes that go beyond his or her *person*. "I ask the question," says Tomás Saraceno: "How can we enter in other worlds? How can we see through the eyes of a spider even though it is blind?"[38]

According to Michel Serres, we now know that it is not only humans but "each element or entity [that] receives, emits, stores, or processes information."[39] We know that trees communicate, that we share most of our DNA with other living species, and that our planet is a fragile structure. Since the human being no longer has monopoly on emissions, we must admit that the point of artistic practice is not to stand out from the undifferentiated background noise of nature by making a statement, but to open up periods of silence that allow us to welcome the manifestations of a world of signs that the artist, since the first

[38] Tomás Saraceno, interview by Clémentine Mercier, *Libération*, October 29, 2018, https://www.liberation.fr/arts/2018/10/29/tomas-saraceno-je-cherche-a-voir-a-travers-les-yeux-d-une-araignee-meme-si-elle-est-aveugle_1688612/.

[39] Michel Serres, *Ecrivains, savants et philosophes font le tour du monde* Paris: Poche-Le Pommier, 2009), 57.

parietal paintings, has never ceased duplicating with his or her own representations. The Western world has blinded itself into considering art as the "double" of reality; in fact, it represents a model for action, a process for activating scattered forces.

FROM OBJECT TO QUASI OBJECT, FROM FORM TO FORMATIONS

> *It rains, it snows, it paints.*
> Daniel Buren

A contemporary art exhibition can be made up of paintings hung on a wall or an arrangement of consumer objects, natural materials, and elements as imponderable as sound, spoken words, actions, or signs. This proves that art cannot be defined as a "class of objects." If that were the case, Yves Klein (who curated the exhibition "The Void" in 1960) or Pierre Huyghe (who has shown a flu virus and housed a hermit crab inside a Brancusi sculpture) would not be artists. Some people are actually convinced that they are not, which spares them the trouble of thinking any further about it. The fact is that artistic activity is neither predictable nor reducible to one type of object, though some would like to confine it within a narrow definition that would confirm their prejudices. But if we must absolutely classify artistic forms, the concept of a "quasi object," coined by Michel Serres, may be useful. The philosopher takes the example of a soccer ball, whose role consists in creating movement between people, but the term also includes "mixed" human and nonhuman processes such as the hole in the ozone layer, climate change, an epidemic, or a traffic jam on a highway. What makes them quasi objects is their ambiguous position (often between nature and culture) and the diversity of instruments that can be used to analyze them, from sociology to science, politics, or aesthetics. In *We Have Never Been Modern* (1991), Bruno Latour extended the concept by enumerating the "hybrids" or "mixtures" we encounter in our everyday lives, from industrialized seeds to frozen embryos, to underline the unraveling of the "purification system" that has long served to separate humans from natural productions. As for Timothy Morton, he prefers the term "hyperobjects," characterized by the way they can spread through time and space, preventing us from identi-

fying their outlines and limits—for instance, the biosphere. Clearly, this interest in half-thing, half-phenomenon hybrids is related to the mutations of contemporary art, which also resists traditional classifications.

Among artists, Philippe Parreno also uses the notion of quasi object, but he gives it a more personal meaning: in his exhibitions, he opposes them to "constant-aura objects" that function continuously as artworks, whatever the context of their presentation. Here, the quasi object is an element of his exhibition that has no meaning outside of it. We should bear in mind that for Parreno, an exhibition is not a static collection of independent objects but a fully fledged medium where relations between subjects, objects, and quasi objects are defined by a presentation protocol that distributes them in time and space. "The exhibition is an automaton," he explains, that is, a machine in which objects interact, synchronized by a computer program. For "Anywhere, Anywhere Out of the World," at Palais de Tokyo in 2013, the exhibition space was activated by an automated system whose program followed the score of Igor Stravinsky's ballet *Petrushka*. In a quasi-Pavlovian reflex, most commentators insisted on the institutional dimension of this feat of computing: point to the moon and they'll look at your finger. For some people, a few decades late in the game, institutional critique is still the epitome of criticism. Their insistence on a subversion *with no outside* is the symptom of an increasing incapacity to read forms and use them as the foundation for a truly political reflection on art: they would rather critique institutions or the spectacle. What Joseph Kosuth once called "protest art" makes the mistake of "not being aesthetically radical," of forgetting the historic relation that connects an artist to the society in which he or she lives: the artist's political conscience must not be "an expressionist appeal" to good conscience but a self-reflective endeavor similar to that of an anthropologist, as we will see further.

As it happens, Parreno's exhibition at the Palais de Tokyo and Huyghe's at the Centre Pompidou, also in 2013, yield their wealth if they are considered as two metaphorical systems and two distinct comments on the fate of art in our societies. Thinking in sequences and chainage, Parreno develops a kind of mechanical climatology. Imperious rhythms structure the spaces of his exhibitions, whose characters are ambiguous: puppets (like Stravinsky's

Petrushka), marionettes, robots, corpses, player pianos.
A partition closes, a curtain opens on a film that is starting,
a sound is triggered, a performance repeats at set times.
Parreno's works, like the replicants in *Blade Runner*, are
composite creatures: their nature is not truly the point, their
destination or their fate are much more important. Accord-
ing to which modalities can a ghost be a part of our life?
Can a robot move us? Where is the limit between the inert
and the living, image and reality, biological determination
and machinic repetition? For his exhibition "Anywhen" Tate
Modern in 2016/17, Parreno created an immersive installa-
tion dominated by sound (the roar of an airplane, the sirens
of a construction site, lapping water, a street singer, rain),
while helium-filled fish floated in the air. Music and movie
sequences, as well as sounds and lights, were triggered by
a colony of incubating yeast, which was connected to the
outside world through sensors on the roof. In this world of
subterfuges, nothing can be permanent: everything comes
to a stop and lights blink, while the images keep coming.
The algorithm, the heart of contemporary industrial pro-
duction just as the assembly chain was the heart of the last
century, is the invisible engine that connects all the pieces
of this mental puzzle. Just as DNA structures life, it rep-
resents the mechanism at work in the logic of the images
organized by Parreno.

As for Huyghe, he treats the living as they are.
He has used the Centre Pompidou and the Hammer Muse-
um of Los Angeles to create artificial landscapes to make
compost, heaping decomposing elements to be used as
fertilizer. He organizes the space into microclimates: ice,
water, mist falling from the ceiling (according to the rhythm
of a story by Edgar Allan Poe, transcribed into Morse code),
and apertures are made in the building to facilitate the
work of bees. Huyghe brings the notion of the cycle to its
logical conclusion: from his refilmings of the 1990s (such as
Les Incivils, which reprised Pasolini's *Uccellacci e uccellini*
shot for shot) to the haunting scenes that gave their tempo
to the three "celebrations" in the video *The Host and the
Cloud* (filmed on Halloween, Valentine's Day, and Labor Day,
2009/10), Huyghe has developed a dramaturgy of repeti-
tion. Under the guise of a festive celebration, he brings to
light another type of repetition, more akin to the concept of
working-through in psychoanalysis. The work of bees may
seem monotonous, but they pollinate their environment.

Such may well be the key to Huyghe's current work:
he sets up cross-fertilization processes of art by nature,
of the human by the animal, and of art by the living, trans-
forming his exhibitions into spaces of *coactivity* where ran-
dom relations between different realms can develop. The
aquarium is an ideal metaphor for this since it houses and
displays coexisting lives. In his aquariums, he immerses bits
of rock, ruins, fish, crustaceans, a hermit crab curled up in-
side a Brancusi sculpture, micro-organisms that take on the
appearance of their milieu. Huyghe explains, "I explore the
equivalence that can exist between what happens inside
the aquarium and an emotion or a situation experienced by
the person who is outside." The museum produces a cul-
tural separation between the living and the still: here, a puff
of steam, streams of water, and wandering animals provide
the uncontrollable element that is a major motif throughout
his work. "Animals have their own way of writing, mistaken-
ly seen as random, and I feel like exploiting that more and
more." The status he clearly assigns to the visitor, that of
an "improvised witness," contributes to the problematiza-
tion of control and provides the possible means to break
free from it: contrary to the spectacular logic of attraction
parks, his exhibitions are inhabited by many characters that
no visitor can be sure of glimpsing. A public writer noting
his impressions on the opening night of the exhibition, an
usher announcing the identity of each new arrival (*Name
Announcer*, 2011), a dog with a pink leg and its handler
wearing a liquid crystal mask, from two different projects,
ants, bees ... So many ways of populating an exhibition,
of creating a spectral, random round where every state
of matter (liquid, solid, gaseous, living, inert) is redistrib-
uted and unsettles our idea of sculpture. It's all a matter
of punctuation: Huyghe introduces commas and periods
into our grammar of the real. Art and psychoanalysis often
come together in his increasingly autobiographical work. A
remembered song, the presence of a sculpture that deco-
rated his school, the sounds of childhood, holiday pictures
... He discreetly introduces the notion of remembrance and
memory as living materials: a turning point that reminds us
of the one taken by Mike Kelley in 1995 with "Educational
Complex," a series of scale models of every school the art-
ist attended and the house in which he grew up in Detroit.
For Huyghe's 2018/19 exhibition "UUmwelt" at the Serpen-
tine Galleries, an individual is shown images and instructed

to re-create these in their mind while their brain is scanned; screens showed reconstructed brain data produced by a neural network with a preexisting image bank. These images evolved according to external factors, such as light intensity, temperature, the presence of insects, or where visitors looked. All the while, thousands of flies hatched in an incubator. "UUmwelt" (with two *U*s) refers, of course, to the "specific worlds" that founded Jakob von Uexküll's biological theories: it is the coordinated combination of specific worlds that yields Huyghe's raw material, a living grammar that encompasses, within the same movement, individual memory and animal behavior, climate and art history, object and phenomena. Because of its immersion in the world, and of the artist's indifference to the categories into which capitalism has cut it up to make use of it, the contemporary artwork presents itself as the product of an *extraction*, a sample collected from an experience, generating more effects in turn.

It would be difficult to understand today's art from the static analysis of its forms, bypassing what drives its most current dynamics and issues—questioning the separation between nature and culture, between subject and object. Paradoxically, this first aesthetic lesson of the Anthropocene turns criticism into an exercise in ballistics, compelling us to envision artworks as the markers of a trajectory, or as machines whose actual size is larger than the space that houses them. In the same way as quasi or hyper-objects emerged on the stage of philosophy to describe phenomena that had been neglected or unknown until then, the concept of *formation* allows us to understand the work of art dynamically, since those we are referring to here cannot be confined to a stable and definitive form. They are formal systems that display themselves while unfolding in a regulated movement, whose outlines are sometimes blurry, whose perimeter may be adjustable, while the relationship between their components may vary or evolve.

As an aside: though the concept of formation suits the *choral* works that are becoming increasingly common these days, it does not express an organicist vision of art, or some sort of vitalism that would put an "equal" sign between art and the living. If we must refer to an existing field of knowledge, rather than holistic or vitalist modes of thinking, we would turn to Lacanian psychoanalysis. To the modes of expression of the unconscious, identified by

Freud as dreams, forgetfulness, witticisms, faulty acts, or symptoms, Jacques Lacan gave the name "formations of the unconscious." Despite their heterogenous character, their common point is to be the (more or less) disguised expression of a repressed desire or of an unconscious wish. But we can only envisage them as dynamic objects, in no way as immutable and definitive forms. In the same way, the division between *subject* and *object* is irrelevant in psychoanalysis, whose discursive regime arises from a triangulation between the Real, the Symbolic, and the Imaginary.

Dissolving art within the totality of the living would make no sense. However, considering certain works of art as formations rather than finished forms, as generators rather than simply containers, as samples lifted from an experience and liable to trigger new ones, allows us to emphasize the temporal or spatial plurality that compose them. We cannot understand Huyghe's *Untilled*, for instance, if we don't have a broadened concept of the artwork at our disposal that allows us to understand, at the same time, the various human, animal, and biological fluxes it is made of and that disseminate it toward multiple futures.

PORTRAIT OF THE ARTIST AS A BUTTERFLY

> *Certain birds have different calls according to the seasons.*
> *Some, too, change their raucous song with the weather.*
> Lucretius

> *A spider conducts operations that resemble those of a weaver, and a bee puts to shame many an architect in the construction of her cells.*
> Karl Marx

Elaborating a contemporary aesthetics of the Capitalocene means thinking artistic activity as a set of procedures that may vary according to periods and places, and that consists in emitting signals intended for other humans, granted, but within a huge sphere of animal, vegetal, mineral, or atmospheric inscriptions. Human art is an emission regime that can be distinguished from the others by its deliberate and reflexive character, by fiction as well, but it is one

that stands in the thick of a vaster *semiosphere*. Another one of its particularities is that art creates a space for the emissions of other species and for the *coactivities* that entangle the human and the nonhuman to become visible. In the same exhibition, organic growth can exist alongside the work of a machine, and human relations can be filtered through an algorithm. But the cooperation of artists with plants, animals, or robots is nothing new. Twentieth-century artists widely practiced *delegation*, inventing frameworks within which they let natural elements or machines produce or even compose their work. Thus, Yves Klein hung a canvas covered in pigment on the roof of his car on the way to the south of France, subjecting it to natural elements (*Vent Paris-Nice*, 1961). Andy Warhol, Gerhard Richter, and Sigmar Polke used the characteristics of new reproduction techniques to elaborate images whose parameters would not be entirely under their control. The inclusion in artworks of natural processes such as growth or decomposition was also a central theme of Italian Arte Povera in the 1960s, while at the same time Ana Mendieta explored the symbolic dimension of her own body from a feminist perspective. Connection with industrial production is another major theme of the century, either as a motif (e.g., Francis Picabia, Fernand Léger, Marcel Duchamp) or through the use of machines themselves (from László Moholy-Nagy's "telephone pictures" to Jean Tinguely's mad mechanisms). But at the time, the two figures—industry and nature—seemed dialectally connected, inseparable from one another. Since the 1990s, the works of Carsten Höller, who wrote his thesis on the role of smell in insect reproduction, are often the outcome of a *cooperation* with birds or mushrooms. He admits he is particularly intrigued by the latter, because "mushrooms are purposeless, apart from being the fruiting bodies of a much, much larger underground life form that needs to spread its spores with the wind."[40] More recently, Anicka Yi's bacteriological sculptures or the spiderwebs of Tomás Saraceno (who also integrates carbon dioxide, cosmic dust, radio frequencies, or air traffic lanes in his works) demonstrate the importance of the micro-living in today's art.

[40] Carsten Höller, in conversation with Olivier Zahm, *Purple* 76, no. 29, 2017, https://purple.fr/magazine/purple-76-index-issue-29/holler-carsten/.

If the avant-garde artists of the past century adopted the gaze of the machine or subjected their works to natural elements, the relationship our contemporaries have with these two fields has changed completely. The common point between Andy Warhol and Yves Klein, to take two major artists of the 1960s, was the industrial matrix of their production. Warhol fully embraced the metaphor, going as far as saying he wanted to "be a machine"—that is, impersonal, without affect, repetitive. But Klein, though he worked with natural elements like air, void space, or fire, seemed to consider them not as autonomous forces, but as available, appropriable materials. In the second half of the twentieth century, starting with Klein or Piero Manzoni, Marcel Broodthaers's series of glued-together mussel shells, Pop art, Land art, Conceptual art, or body art, artists exploited their everyday world or elements taken from their environment, becoming either the entrepreneurs of their own existence or employees serving the natural forces, whose action they embraced by signing their name to it. The industrial model was dominant and shaped the relationship between artists and nature; for them, it was most often a *critical identification* in which the work embodied or rendered visible the catastrophe it reported. A few mavericks like Giuseppe Penone or Ana Mendieta would, as of the 1970s, start merging the human body with the living organisms in their work. But for the most part, the art of the period remained within the confines of Western ideology, with an invisible wall between nature and culture.

The evolution of mentalities encapsulated by the term Anthropocene concerns the position of the artist in the world as the demarcation between mankind and its environment becomes increasingly blurry, and as a purely instrumental relation to nature yields to a harrowing feeling of *immersion* in a perishable sphere. With the agricultural revolution of the Neolithic period, the human species no longer felt immersed in its milieu, but rather took control over it. If the Anthropocene is well and truly a "crisis of the human scale," as defined earlier, it is because this control program is now reaching its limits between the two infinite realms of the minuscule and the immense, the viral and the global. There would be much to write about the Western artists who, since the birth of modern art, kept alive a connection with loss of control, by advocating a kind of *duty of immersion*—whether this letting go to outside forces

came from deliberate dispositions, the use of drugs or the exploitation of dreams. When Salvador Dalí practiced his paranoiac-critical method daily, when Henri Michaux drew under the influence of mescaline, when Marina Abramović abandoned her body for six hours to the good will of the public of her exhibition,[41] art became an *uncontrolled* space where the human being asserted his or her immersion in a greater context. In a letter written in 1817, the poet John Keats embraced the "negative capability" of the artist, "that is, when a man is capable of being in uncertainties, mysteries, doubts, without any irritable reaching after fact and reason." Here we will discuss a romantic version of inclusive thought.

The end of the hylomorphic system led to a paradigm shift in thinking, summed up by Claude Lévi-Strauss when he asserted that "the mind accomplishes operations that do not differ in nature from those that have been unwinding in the world since the beginning of time."[42] At last, human thought was reintegrated within the biosphere's biological framework in the same way as animal secretions or pollination: expressions of the world, just like art, that differ only in their complexity. Roger Caillois drew the same conclusions: "More and more, I envision imagination, intelligence, the capacity to dream, the power to speculate correctly as general properties of the universe."[43] This vitalist vision of human thought, which seems to naturalize it, leads us to ask what substance art is made from and its functions. Is it a human exception, or the very expression of the world, that could be included in its *general production*? Lévi-Strauss's position, as Philippe Descola summarizes it, defines nature as "a sort of lexicon of distinctive traits which the organs of the senses and the brain use to produce texts according to their own syntax."[44] Producing meaning would therefore be extracting signs from a milieu

[41] Marina Abramović, for the performance *Rhythm 0* (1974), left instructions for the audience: "On the table, there are 72 objects with which you can do what you want. Performance. I am an object. I take responsibility for everything that will happen in this time frame."

[42] Claude Lévi-Strauss, *The View from Afar*, trans. Joachim Neugroschel and Phoebe Hoss (Chicago: University of Chicago Press, 1985), 164–65.

[43] Roger Caillois, "Le Fleuve Alphée," in *Oeuvres*, 136.

and recomposing them. All that exists, Emanuele Coccia explains, is the product of the metamorphosis of a same body: the vegetal turns air and stone into living matter, and there is "absolute intimacy between subject, matter, and imagination: to imagine is to become what one imagines."[45] Here, Lévi-Strauss's monist vision is relayed: clearly, aesthetics, like ethics, is an *analysis of a milieu* and the *faculty to transform it*.

When Cicero wrote that "all nature is an artist since it has ways and means, to which it adheres,"[46] when Democritus compared the artist to a spider or a swallow, when Aristotle saw the principles of drawing in the composition of bodies, they are just expressing what was a truism in their day: art proceeds from nature; the artist sets him or herself the task of representing and expressing its key elements and structures. But while at first glance, many contemporary works seem to agree with this principle, they do so via a novel viewpoint, characteristic of the Anthropocene: catastrophe. For Michel Serres, "Our ancient cultures opposed cultures with writing and nature without writing [while] the new embraces cultures without writing and nature with writing."[47] This awareness expresses belated remorse toward people long considered "inferior," but it is also an acknowledgment of the animal and vegetal world as a semiological power.

But art, we are told, is a characteristic of the human species. The universal classification produced by Caillois (demonstrating that all existing forms come into being through growth, an accident, a mold, or a project) seems to designate the work of art as belonging to the last category, while animals or plants merely follow the organic laws of their species. But isn't our propensity to set ourselves apart from the natural order rhetorical, or even ideological?

[44] Philippe Descola, *The Ecology of Others*, trans. Janet Lloyd (Chicago: University of Chicago Press, 2013), 23.

[45] Emanuele Coccia, *The Life of Plants: A Metaphysics of Mixture*, trans. Dylan J. Montanari (Cambridge: Polity Press, 2018), 12–13

[46] Cicéron, "De la nature des dieux," in *Les Stoïciens* (Paris: La Pléiade, 1962), 429.

[47] Serres, *Ecrivains*, 104.

Are we certain that the urges that drive a human being to produce forms are radically different from those that drive the whole of the living world? And what isn't "natural" in the world? A species apart, granted, but still a species, human-kind is in denial as to its exceptional status, believing that outside of its realm, all forms merely respond to necessity, since nature produces nothing in vain—which is to say that it only generates useful forms, according to our own nar-row logic. For Caillois, this vision is mistaken: "Enormous dilapidation is the law," he said, among plants and animals; a "lavish expense, with no intelligible purpose" that contra-dicts the opposition between the art of humans and nonhu-mans in terms of usefulness and gratuitousness.[48] Carsten Höller questions the role of mushrooms in biological life: "Why all these forms, colors, ingredients in mushrooms, some of them extremely toxic and some very pleasant to the human palate? It's not about communication and not about self-defence in most cases, as far as we know. It's either truly without purpose, which I would find astonishing [...], or there's something going on there that is happening beyond the reach of the human mind."[49] Does he have a better understanding of art's reason for being? As an au-tonomous category, art depends on a purely human appre-ciations but "as Man himself belongs to nature, the circle is easily closed,"[50] Caillois concluded. Adding that "the real or possible structures of the universe command the idea of beauty,"[51] he agreed with Lévi-Strauss, for whom the hu-man mind only follows *engrams* in the biological framework of the world, or Eduardo Kohn for whom the forest, the wind, clouds, or animals "produce meaning" just as much as humans.

For Caillois, the butterfly and the artist therefore belong to a same family. The former bears on its own wings an organic, apparently spontaneous, *incorporated* artwork. As for the latter, excepting performance art and body art, he or she projects it onto an external medium, and his or her activity is driven by what is called (at least from the

[48] Caillois, "Le Fleuve Alphée," 499.

[49] Höller, in conversation with Zahm.

[50] Caillois, "Cohérences aventureuses," 25.

[51] Caillois, 57.

human standpoint) individual will. In the same way, rather than growing a carapace or a pair of wings, humankind has alway externalized its needs by inventing prostheses, from clothing to airplanes, or by transforming its diet rather than developing a digestive system as complex as that of ruminants. To survive, it had to impoverish itself, to strip itself to the extreme, to rule out the solutions that would durably modify its body, and to acquire, through this externalization strategy, "a greater diversity of efficient behaviors." Reversing the usual terms of comparison, Caillois defined the insect as "an introverted technician" and urged us, rather than the opposite, "to present the pictures of artists as the human variety of a butterfly's wings."[52] Artistic activity "is a particular case of nature" and represents our contribution to a universal phenomenon.[53] From this point of view, the artist is nothing more than the "rival of a universe to which he participates." Botany or geology turn out to be inseparable from what the West came to call abstract art in the twentieth century:[54] for a very long time, every book on abstraction had to include a passage on the unavoidably figurative nature of painting by including images of sodium chloride crystals seen through a microscope or aerial views of the coast of Brittany.[55] To look at more contemporary examples, it's true that Gerhard Richter only paints *real* things, whether they're photographs found in a trunk or sulfur molecules; and the work of Per Kirkeby, abstract as it may seem, shows mineral strata and humus. "It's as though," Caillois continued, "[the artist] aimed, without being aware of it, to achieve [...] the perfect equivalent of the compositions of motifs and colors produced over the millennia by geology, blindly following blind and inflexible laws."[56] Let us note that Caillois's personal collection included a work by K'iao Chan, a nineteenth century Chinese painter and a brilliant forerunner of the readymade, who signed, titled,

[52] Roger Caillois, "Méduse & Cie," in *Oeuvres*, 494–98.

[53] Roger Caillois, "Cohérences aventureuses," 25.

[54] Just to take one example, three centuries after the monochromes of Indian tantric art.

[55] See, for instance, Dora Vallier, *L'art abstrait* (Paris: Hachette Pluriel, 1980).

[56] Caillois, *Oeuvres*, 502.

and framed an especially expressive piece of marble.[57]

The Swiss zoologist Adolf Portmann (1897–1982) studied animal aesthetics all his life. He considered the stripes of mammals, the colors of fish, the patterns of butterflies, the glossy or iridescent effects of bird feathers, the geometric design of seashells as "plastic formulas" of the expression of animal individuality. According to him, feathers, scales, and furs should be seen as "organs of display"—what we call skin appendages.[58] Portmann invented "phanerology," the science of displays produced by living beings. He wrote: "All creatures endowed with a relation to the world also possess the characteristic of self-representation, which has too often been unrecognized until now. *The parts necessary to the relation to the world* are fashioned each time according to a peculiarity typical of the group, a singularity that expresses itself through many structures and many modes of behavior whose specificity cannot merely be explained by the simple conservation of the individual and of the species."[59]

Self-representation: in other words, the presentation of individuality through visual forms, in view of communicating ... It seems that human art belongs to a much vaster world than the one to which we reduce it:[60] first, biology (the inscription of visual appearances within life itself), then metaphysics (because in both cases, this inscription goes beyond the notions of survival or organic function). What Portmann and Caillois endeavored to explore was the meaning of living forms in general, and in this they both anticipated the great realization of this century, one that likely arose from the Anthropocene: "The world beyond the human is not a meaningless one made meaningful by

[57] Another work by K'iao Chan is displayed in the Natural History Museum in London. Its place should be in an art museum.

[58] Translator's note: *Phanères* in French, hence "phanerology."

[59] Adolf Portmann, *La vie et ses formes* (Paris: Bordas, 1968), 158 (emphasis mine). For Portmann, animal self-representation, like human art, is by essence relational.

[60] "Appearance is a vital function," Portmann explained, reaching the same conclusions as Caillois.

humans,"[61] to quote Eduardo Kohn. Or, to say it differently: the world exists beyond the relation between a human subject and objects, beyond the division between nature and culture. But unlike the thesis championed by speculative realism, what goes beyond this restrictive formula is not necessarily an arche-fossil belonging to the great outside of the nonhuman. We now know that our body is inhabited by billions of bacteria and enzymes, a revelation unconceivable in past centuries. It is neither bolder, nor more absurd to imagine that art is not an isolated production occurring in a universe of mute objects, but that it takes place within the broader field of "display organs," of phanerology and self-representation.

In her video *Swallow* (2013), Laure Prouvost presents an idyllic, sunny natural setting, a waterfall where a small group of naked figures play in a river, manipulating or ingesting fruit. The editing is very choppy, alternating between wide and tight shots of mouths that inspire, suck, expire; of stained fingers or of a fish that seems to be swallowing raspberries. The extreme sensuality of the images, associated with a soundtrack of bodily noises and amplified whispers, abolishes the difference between inside and outside, subject and object. The broken glass, falling drops of water, snapping fingers that lead to a changing shot, create a genuine indistinction between the fields of perception and narration, as though the image were just an extension of the nervous system, itself turned into a landscape. Another video, *It, Heat, Hit* (2010), starts with a shot of smoldering embers, interrupted by the words "it smells red." Organizing the confusion of the senses, Prouvost's work is physics of fluids which constantly redistributes realms: potted plants express demands ("No one wants me / They do not let me grow / I can hear my leaves falling ..."); we don't know who is talking, nor to whom, a situation all the more disturbing that the beholder is often hailed and ordered to perform such or such an action.

In a passage of his *Economic and Philosophic Manuscripts of 1844*, Karl Marx used a striking expression to define nature. It is, he wrote, "the inorganic body of Man."[62] It is a body, and this body is also ours. It becomes *inorganic* when it enters the cycle of human activities. A tree is organic until it is cut up into logs. It then becomes

"inanimate," waiting to enter a world where, once it has become a product, it will acquire the magical properties of a fetish glowing with the halo of its monetary value. Which is to say that this log, transformed, for instance, into a material for the production of an industrial object, severed from all living reality, will enter the "spectral dance" of capitalism, where objects "dance" like specters because they now live through their exchange value, while the subjects who fashioned them are only the objects of a production process. Even more than profit rates or free trade, the essence of the capitalist mode of production is reification. My aim is to demonstrate that today's art endeavors, instead, to re-subjectify and reanimate this reified world: in other words, as the artists quoted above said, to intensify the presence of what is or to empathize with things. What is the actual difference between art and magic? Art has evacuated credulity: it is a magic without illusions that persists in reenchanting, within a critical perspective, a world dried up by the capitalist production process. If magic generates a certain type of art, it will present itself as an exercise in petrifying the living—terms that already described *l'art pompier* of the nineteenth century in France (frozen, hieratic, and marmorean).

Since the end of the last century, a new current of thought has attempted to open a breach in the barrier erected by the West between human and nonhuman worlds, in an ideology that "reserves the privilege of sociality to everything which is not deemed natural,"[63] as Philippe Descola sums up, and calls *natural* as that which it intends to enslave. The British anthropologist Alfred Gell argues to consider works of art as persons: "The immediate 'other' in a social relationship does not have to be another 'human being'. [...] Social agency can be exercised relative to 'things' and social agency can be exercised by 'things' (and also animals). [...] It just happens to be patently the

[62] On the question of the "inorganic body of man"
and the supposed anthropocentrism of Karl Marx,
see Judith Butler's fascinating essay "The Inorganic
Body in the Early Marx: A Limit-Concept of Anthropo-
centrism," *Radical Philosophy* 2, no. 6 (Winter 2019),
https://www.radicalphilosophy.com/article/
the-inorganic-body-in-the-early-marx.

[63] Philippe Descola, "Human Natures,"
Social Anthropology 17, no. 2 (May 2009): 145–57.

case that persons form what are evidently social relations with 'things.'"[64] To formulate a theory of art that would be truly universal, that is, capable of including works that don't come from within an organized art world or a network of institutions that would validate it, he puts forward the notion of *agency*. According to him, the anthropology of art must presuppose an equivalence between persons and objects of art, which therefore become "quasi subjects" or "social agents."[65] And they are not separable from their context, just like people: "artworks come in families, lineages, tribes, whole populations."[66] Like them, they are part of a network of alliances, descendants, and exchanges. In other words, Gell analyzes artworks based on their *action* on reality, as though "they had 'physiognomies,' like people." Indeed, they are at the heart of human interactions and sometimes cause them: "When we see a picture of a smiling person [...] the appearance of smiling triggers a (hedged) inference that [...] this person is friendly, just as a real person's smile would trigger the same inference. We have, in short, access to 'another mind' in this way."[67] Because it has allowed us to access "another mind," the artwork functions, in anthropological terms, as a mode of *intercession*. It establishes a *relation*, a connection with levels of reality we could not access on our own. Guy Debord proposed a different point of view in *The Society of the Spectacle* in which he saw the "living" character of images as an effect of social alienation: "When the real world is transformed into mere images, mere images become real beings." Things or representations are *substances* with which human beings have complex connections. The sociologist Arjun Appadurai also speaks of "the social life of things" since every object contains a "social potential" that can be realized through exchange.[68] And for Igor Kopytoff, "societies exert constraints on the

[64] Alfred Gell, *Art and Agency: An Anthropological Theory* (New York: Clarendon Press, 1998), 17–18.

[65] Gell

[66] Gell, 153.

[67] Gell, 15.

[68] Arjun Appadurai, *The Social Life of Things: Commodities in Cultural Perspective* (Cambridge: Cambridge University Press, 1986).

world of things and people at the same time and in the same way, constructing objects and people within the same, single movement."[69]

Within the fuzzy category of *things*, the artwork possesses specific properties. Because it is conceived, produced, or presented by a person or a collective, it is the delegation of a human presence. As a life-bearing practice, art enjoys a specific status since it is "an emanation or manifestation of agency,"[70] to quote Gell. In other words, the trace or the result of an action, a signal that will, in turn, act upon the mind of its receptors. In the Western literary tradition, art is sometimes endowed with the powers that other civilizations attribute to their fetishes; in Oscar Wilde's *The Picture of Dorian Gray* (1890), the painting ages instead of its model, and in Balzac's *The Unknown Masterpiece* (1831), the painter Frenhofer dies because he attempts to turn his painting into an equivalent of life.[71] There is a mythology of *consubstantiation* in Western art, for which the artwork has the power to receive, transmit, or duplicate organic existence, not to mention the belief that it can communicate with "the afterworld." The fact that artworks must be *active*, one of the leitmotifs of modernity, is not dissimilar to the qualities traditionally ascribed to the relic or the fetish. A painting by Henri Matisse or an installation by Joseph Beuys contain their author's life in the same way that some objects, in animist cultures, are meant to contain the spirit of an ancestor or an immaterial power. Isabelle Graw argues that within globalized capitalist societies, painting is the ultimate medium of this fetishization, and even a "model of subjectivity": "Painting's capacity to appear particularly saturated with the life- and labor time of its author, while remaining distinct from it, makes it the ideal candidate for value production in a new economy

[69] Igor Kopytoff, quoted in Octave Debary, *De la poubelle au musée: Une anthropologie des restes* (Saint-Étienne: Creaphis éditions, 2019), 139.

[70] Gell, *Art and Agency*, 20–25.

[71] About the "categoric imperative" of artistic modernity that consists in establishing a connection between art and life (namely, through the three tutelar figures of modern art, dandyism, alchemy, and fantasy literature), see my book *Formes de vie: Une généalogie de la modernité* (Paris: Gallimard, 1999).

that is busy absorbing life."[72] The traces of an individual, intimate activity, reflecting an inner world, take on a unique value in a world where people don't recognize themselves any longer in their professional tasks, and where the data of our leisure is monetized. While work has become abstract and impersonal, art materializes a person's relationship to the world. In painting, Graw explains, "it is all of its signs—iconic or symbolic—that simultaneously evoke the ghostlike presence of their absent author."[73] Remember here that art is the delegation of a presence, and that it speaks to spirits.

The term "spirit" has no religious connotation for me: all monotheist religions have done was to cast the fluctuating multiplicity of the spiritual world into patriarchal figures. The fact that contemporary art is reappropriating the complex notion of spirit, and that the artist is reclaim-ing an *agency* analogous to a shaman's within a chain of human and nonhuman agents, in no way rejects the critical, self-critical, and reflective dimension that arose from mod-ernism. Remember that Beuys, in an action performed in Düsseldorf in 1965, wanted to "explain painting to a dead hare." His head covered in honey and gold sheet, he whis-pered into the ear of the animal's corpse for three hours, while the public crowded outside the gallery. From time to time, Beuys got up to step over a withered fir branch on the ground: "When I work with animals, of course I suppose that people understand it is a position towards the world of which they are no longer truly aware: for instance, we no longer pay attention to the differences in value within nature, between minerals, plants, animals and humans. [...] To put it simply: I take an animal to work on a whole other level of reality, and to point out that it is an essential part of Man."[74]

The aesthetic regime of the Capitalocene could be summed up by the feeling of immersion in the world, the radical disruption of our representations of the *outside*, the irruption of a crisis of the human scale that affects our conception of the *exterior*. It manifests itself through the

[72] Isabelle Graw, "The Value of Liveliness," in *Painting beyond Itself: The Medium in the Post-medium Condition* (Berlin: Sternberg Press, 2016), 101.

[73] Graw, 81.

[74] Joseph Beuys, *Par la présente je n'appartiens plus à l'art* (Paris: L'Arche Éditeur, 1988), 108–9.

quest for interlocutors: Who do we speak to? In what language? Let's listen to Christian Boltanski here:

> The Indians of South America think that whales know the beginning of times, and since that's a question that obsesses me, I built huge horns with acousticians, that imitate the language of whales, in a deserted area where they are very numerous. Naturally, they never answered. Those horns will certainly be destroyed by storms, and no one will have seen them for real. Maybe the idea will remain that a madman came there to speak to the whales. The story doesn't even need a medium anymore. The fact that things exist becomes almost more important than if they are seen.[75]

The visual field of the human being is a cone. When an artist organizes lights, colors, and forms according to his or her visual field, he or she can resort to perspective, or to the representation of a foreground and background, but these are conventions that arise from ideologies, from world views. As we have seen, plastering a human figure against a background (a "landscape") is quite simply ignoring the event of the Anthropocene, which translates into the collapse of these spatial hierarchies, the collision of various realms and states of matter, and above all the accession of nature to the rank of a fully-fledged subject. There is no such thing as space on one side, its occupants on the other, only networks of semiotic and material connections between agents who form, at a given time and place, "fields of subjectivation."[76] In other words, the human being is not an isolated orator in a mute environment, but the protagonist of an opera whose other musicians he or she has muted. Europeans seem to live in a world where other living creatures are only part of the environment. A figure against a background: this is the way humans have

[75] "Christian Boltanski Mythologist," interview by Nicolas Bourriaud, *artpress*, no. 472 (December 2019).

[76] While the concept of a "field of subjectivation" was coined by Michel Foucault, we can also refer to Bruno Latour in *Reassembling the Social: An Introduction to Actor-Network-Theory* (Oxford: Oxford University Press, 2005).

represented themselves in the West for two thousand years, reflecting their conviction that they are the center of a planet that is the center of the universe. From the Fayum mummy portraits that accompanied first-century Egyptians in their sarcophaguses to nineteenth-century European history paintings, the history of art shows us human figures clearly delineated against natural environments, domestic decors, the gold backgrounds of Byzantine icons, the architectural perspectives of the Italian Renaissance, in the midst of tree-lined landscapes.

As monotheistic religions teach us, man was created in the image of God (whose gender is, it should be pointed out, always masculine) and nature is just a backdrop for his actions, a stage the human being can arrange as he or she pleases. If Impressionist painting caused such a scandal in its day, it is because it was the first to dissolve the outlines of the human being and to dilute them into the atmosphere, because Monet's or Pissarro's strokes overlapped on figures rather than isolating them through modeling forms: in the nineteenth century, painting a human being in the same way as what were considered his *accessories*—objects, nonhumans, landscapes—was the ultimate provocation. It is this ideology of representation (figure/background), in line with the biblical conception of the human being as "master and possessor of nature," that is crumbling today. And with it, the conception of art before our era, put forward by Aristotle in the fourth century. The artists of the Anthropocene have learned that everything is matter, that nothing can constitute an undifferentiated and inert background onto which an activity is affixed. This new mental regime draws together spheres that were once separate: the vegetal, the animal, the mineral, the molecular, the robotic, and the social have turned out to be interdependent, constantly echoing one another. It is precisely between the figure and the background, the two poles of Western aesthetics, that we can find the space induced by the Anthropocene, an *inclusive* space. "Together we work on grasping the ecosystem," Tomás Saraceno explains. "Art can help us see this multiplicity of scales and phenomena, use a multi-lens to show that we co-exist and share the space with more-than-human beings."[77]

[77] Tomás Saraceno, interview by Vanessa Oberin, *Friends of Friends*, July 2017, https://www.freundevonfreunden.com/interviews/tomas-saraceno-wants-to-fly-while-keeping-his-feet-on-the-ground/.

THE ADVENTURES OF MANA, OR ART AS SUBSTANCE

> *No, the concept of art must replace the degener-*
> *ate concept of capital. Art is tangible capital and*
> *people need to become aware of this. [...]*
> *The capital is human dignity and creativity.*
> Joseph Beuys

In postindustrial societies, we generally perceive the artist as being outside the productive system. But he or she is often associated with squandered money, scandal, ec-centricity, madness, or antisociality. Contemporary art is disparaged because it is considered hard to understand, composed of hermetic ideas and forms. In this, it is related to what theology calls *gnosis*, a form of knowledge that is esoteric, subversive, and sectarian. Modern art (then art qualified as *contemporary*, to distinguish it from the era of radical utopias) works as a *password* that connects differ-ent social strata while operating as a sign of distinction. The sociologist Pierre Bourdieu meticulously studied this distinction, constitutive of class societies for which culture is endowed with the virtues of transferable capital.[78] While we're on the subject of social values, let's admit that those conveyed by the art of the past two centuries have turned out to be hard to digest for the productive system: praise of laziness, refusal of the system, provocation, esoterism, irra-tionality, complexity, gratuitousness ... What contemporary art is condemned for is everything that makes it a pocket of resistance to the society of control. Including its so-called elitism.

 Anthropology is what will help us shift our gaze in order to perceive the world of art as something other than a luxury industry. First, let's examine the main sociological themes that circulate in contemporary art exhibitions:

> a) The sources of segregations: the privatization
> of public space, the repression of minorities, the
> mechanization and depersonalization of bodies,
> the overvaluation of their functionality.
> b) The disappearance of cultural diversity,

[78] Pierre Bourdieu, *La distinction: Critique sociale du jugement* (Paris: Éditions de Minuit, 1979).

the standardization of the world, and its corollary: identitarian closure.

c) The critique of scientific rationalism and of the exploitation of the living, various forms of ecological thought.

d) The restructuration of existence by patriarchal capitalism, transforming women's activities into a labor of procreation and assistance; the resurgence of the idea that nature, earth, and women belong to the symbolic domain of "nurture."

Strangely, the common point between all these themes is that they could pass for pre-Columbian, in the sense that they question the roots of a civilization founded on the historical pillars of colonialism and productivism. Western modern art is, in various ways, a ferocious indictment of the labor value that is at the heart of capitalism. During the Renaissance, capitalism slowly established itself with the invention of abstract labor and technical progress, but also through what Michel Foucault called "the great confinement," which affected the whole of the social body.[79] In his *History of Insanity in the Age of Reason* (1961), he describes the medicalization and reclusion of the insane, vagrants, homosexuals; of all those who thwarted the establishment of the new social order. Silvia Federici, in *Caliban and the Witch* (1988), addresses an aspect neglected by Foucault: the oppression of women, namely, through the criminalization of the witch. It was in the sixteenth and seventeenth century (rather than the Middle Ages, as is commonly believed) that a wave of persecutions swept across Europe, and it affected mostly women—only 20 percent were men, who were classified as "errant,"[80] Here,

[79] Foucault saw the great confinement, which led to the invention of modern prisons, hospitals, and psychiatric asylums, as corresponding to the economic rationalization of labor in European societies from the end of sixteenth century—the enclosure marking the end of the commons and the exclusion of women.

[80] For detailed narratives of this exclusion process, see Michel Foucault, *A History of Insanity in the Age of Reason* (1961; repr. London: Penguin Random House, 1965); Federici, *Caliban and the Witch*; or Mona Chollet, *Sorcières: La puissance invaincue des femmes* (Paris: La Découverte / Zones, 2018).

witchcraft must be considered as an embryonic form of class struggle. If inquisitors persecuted rural witches and magicians so fiercely, it was because they were "primitive rebels," as Eric Hobsbawm calls them.[81] The "great confinement" of deviants, vagrants, and the atypical, the backdrop of a general movement of privatization and rationalization of the world, went along with the privatization of natural resources and the establishment of an institutional monopoly on the hereafter. "Unregulated" intercessors were marginalized, while a control of representations organized the lives of artists, at least until the appearance of the avant-gardes.

To set itself in motion, productivist capitalism entailed a *purification* of labor, its reduction to an abstract essence (money) and, therefore, the marginalization of its most concrete components: first, the work of nature (forests filtering the water we drink, bees pollinating crops, bacteria allowing fermentation), then of domestic tasks (by creating a feminine underclass) and of collective work (by confiscating the commons), but also of every non-quantifiable activity, with the exception of duly accredited religions. Why, at that moment in history, weren't artists excluded just like other "deviants"? Probably because representation could be used socially. Productivist societies integrated art by institutionalizing it as an industry of the image, and then in the form of (luxury) products commercialized on a marginal market. As Jonathan Crary writes, "The vitiated role of the visionary was left over for a tolerated minority of poets, artists, and mad people. Modernization could not proceed in a world populated with large numbers of individuals who believed in the value or potency of their own internal visions or voices."[82] It was only in the middle of the nineteenth century that European artists were able to reestablish a common space that would enable them to assert their "deviance." From Gustave Courbet to Jackson Pollock, modern art relentlessly questioned the premises of the economic modernization of the world, namely, through the critique of mechanization. These dissident artists were called "modern," in opposition to tradition, but the tradition their detractors invoked had nothing to do with concrete

[81] Eric J. Hobsbawm, *Primitive Rebels* (Manchester: Manchester University Press, 1959).

[82] Jonathan Crary, *24/7: Late Capitalism and the Ends of Sleep* (London: Verso, 2014), 106.

ancestral knowledges—quite the opposite. Behind the tradition that was opposed to modern art, we find the frozen codes of a reassuring bourgeois art: academism.

Instead, the moderns returned to concrete, earlier traditions, to forgotten historical knowledges—starting with the African sculptures that influenced the Fauvists and the Cubists. Contemporary art teems with magic principles, totemic forms, and archaic motifs, and today many artists embrace values drawn from precapitalist societies. What artist can we quote here, if not the most unexpected, precisely because he turned the manufactured object into the norm of all artistic production? Marcel Duchamp saw the artist as "a strange reservoir of spiritual values in absolute opposition to functionalism [who] must conserve the great spiritual traditions with which even religion, it would seem, has lost contact, [...] keep the flame of inner vision, of which the work of art is perhaps the most faithful translation for the profane."[83] The spiritual tradition that Duchamp intends to uphold is related to gnosis, magic, or poetic wandering, evacuated from the social field by the great confinement of the Classical Age. And since religions were the accomplices and auxiliaries of this operation, it is in the field of art that we will find "the most faithful translation," distilling "anti-functionalist values" for "the profane." It is for this reason that, as Duchamp claimed in a 1961 conference in Philadelphia, "the great artist of tomorrow will go underground." In an essay on Duchamp, Jindřich Chalupecký underlines the fact that "our civilization was the first to have lost the feeling of contact between the conscience and what is beyond it" and sees the author of the *Nude Descending a Staircase* (1912) as the prototype of the artist who "surrenders to the unknown, the non-explainable, to this immense *I don't know*," in other words as "a witness to transcendence."[84] This "non-knowledge" (Georges Bataille called it *le non-savoir*) was once in suspension in the space of common magic. Banished, it ultimately took refuge in art.

In his *Introduction to the Work of Marcel Mauss* (1950), Claude Lévi-Strauss also addressed the wave of

[83] Marcel Duchamp, *Duchamp du signe* (Paris: Flammarion, 1975), 238.

[84] Jindřich Chalupecký, "Art et transcendance," in *Marcel Duchamp: Colloque de Cerisy* (Paris: Union générale d'éditions, 1979), 22–30.

exclusions associated with the emergence of capitalism in Europe at the end of the Middle Ages, namely, through the pathologization of magic. Medieval sorcerers and witches were demonized, just as colonialist repression would later war against African shamans or possessed persons. In *A General Theory of Magic* (1902), Marcel Mauss noted that "the magician's simulation is of the same order as that which is observed in neurotic states [...] the disabled; the ecstatic; nervous types and outsiders, really constitute kinds of social classes."[85] Social classes: Mauss reminded us that outsiders and magicians were victims of the great confinement in the same way as the insane, sexual "deviants," witches, and women in general. Lévi-Strauss insisted: "By what criterion should we treat as abnormal some individuals who match the group average, who can draw on all their mental and physical capacities when going about their everyday life, and who occasionally display a meaningful and socially-approved mode of behavior?"[86] So why, indeed, wasn't Chris Burden committed in 1971, when he shut himself away in a locker for five days for a piece of performance art?[87] Why wasn't Malevich when he made a white on white painting? Or Maurizio Cattelan when he stuck a banana on a wall in Miami with two pieces of black tape? Most artistic behaviors and actions, from Dadaism to our day, might have once led any of their authors to be locked up in an asylum if we lived *in a society without art*. To understand why this isn't the case, you just need to replace the words "shamanistic behavior" with "art" in Lévi-Strauss's argument: "For the very reason that shamanistic behavior is normal, certain modes of behavior can remain normal in shamanistic societies which, elsewhere, would be considered (and would in fact be) pathological."[88] It so happens that we do live in societies "with art" just as others are "with shamans": there is a space for it. If this is now com-

[85] Marcel Mauss, quoted in Claude Lévi-Strauss, *Introduction to the Work of Marcel Mauss*, trans. Felicity Baker (1950; repr. London: Routledge & Kegan Paul, 1987), 14.

[86] Lévi-Strauss, 15.

[87] Chris Burden, *5 Days Locker Piece*, 1971.

[88] Lévi-Strauss, *Introduction to the Work of Marcel Mauss*, 20.

monly admitted for contemporary art, Mauss argued that magic was once considered a language: "In sum, as soon as we come to the representation of magical properties, we are in the presence of phenomena similar to those of language." And just as magic comes under the competence of linguistics, we can apply to it the methods of a then-fledgling science, psychoanalysis, since "in magic, as in religion, it is the unconscious ideas which are the active ones."[89] If, in our times, art reveals the collective unthought or criticizes ideas *that go without saying*, we can easily conceive that this function was once the prerogative of those who had magical powers in the community, of jesters, or of the insane. What's more, the exclusion of deviant or irrational behaviors and practices by Western societies generated modes of representation that were deemed acceptable. The so-called tradition in whose name modern artists were stigmatized throughout the twentieth century, just like their successors today—namely, for their lack of respect for their "craft"—is just another name for the normalization that went along, as of the Renaissance, with the establishment of the capitalist system. We can be fascinated by Tuscan painting, admire Giovanni Bellini or Sandro Botticelli, while acknowledging their involvement in this historical process. In other words, what is truly traditional is not the type of realistic representation that was imposed in the West during the great confinement, but the contemplation of geometric figures or mandalas, painting one's body, or attending esoteric rituals. Contemporary art is connected to these zones of magic, more than to the centrist, monocular perspective that triumphed in the Classical Age. To understand twenty-first century art, we must look beyond the narrative of the historical evolution of European styles and see how it operates a political and ideological reconnection with precapitalist times and so-called primitive societies.

First, we should identify the common trait between magic (in the past or other cultures) and today's art. What makes it the heir to the ancient space where magic, esoteric practices, vagrancy, and deviances intermingled? In what way did these marginalized activities form a coherent whole? In every human community, there is a zone that is too often encapsulated by the *sacred*, a notion that has ended up attracting energies and channeling them into

[89] Mauss, quoted in Lévi-Strauss, 34.

institutional forms, readily bestowed on artworks.
In trying to understand the true nature of this space, whose
form varies according to the structure of different societies,
but whose contents depend on social organization (into
which multiple agents can be funneled), I was struck by the
way, at first glance enigmatic, in which Lévi-Strauss prob-
lematized the "intellectual condition" of the human being:
"The universe is never charged with sufficient meaning
and [...] the mind always has more meanings available than
there are objects to which to relate them."[90] In his book on
Marcel Mauss, Lévi-Strauss elaborated on the idea: for the
human being, he said, there is always "a signifier surfeit
relative to the signifieds to which it can be fitted. So, in
man's effort to understand the world, he always disposes
of a surplus of signification."[91] To put it differently, the hu-
man being feels the need to totalize and explain the world
that surrounds him or her, but there are not enough signs,
and there are few spaces and forms to "hang" them on to.
We are surrounded by the unexplainable, and the progres-
sive elucidation of the enigmas of life only push back the
boundaries of its mystery, reconfiguring the space as soon
as it is filled by such or such mythic or scientific explana-
tion. This "surplus of signification" is the element that is of
interest: unlike overproduction (which only creates waste),
it is related to the surplus energy Bataille depicted as the
world of *excess* that creates a powerful connection be-
tween art, sex, wastefulness, religion, or luxury, grouped
under the term "sumptuary expenditure"—a *solar* econo-
my, profuse and unrestrained. We could also compare this
strange "surplus" with the *objet petit a* of psychoanalysis
(unattainable object of desire), which Jacques Lacan de-
scribed as the central void around which the wheel of
representations revolves in the human unconscious: the
throbbing heart of the chain of signifiers, the place where
all psychic contents stumble or come to rest. The fact re-
mains that the fundamental drive of the human being (to
explain, to give meaning to things and phenomena) requires

[90] Claude Lévi-Strauss, "Magic and Religion,"
in *Structural Anthropology*, trans. Claire Jacobson
and Brooke Grundfest Schoepf
(New York: Basic Books, 1967), 165–85.

[91] Lévi-Strauss, *Introduction to the Work of Marcel
Mauss*, 62.

the existence of a field of signs onto which meaning can be "hung": once, this was magic, but now it is art that supplies us with the mental equipment we need to survive in our jungle. Could we imagine a world from which representations have disappeared, that has evacuated any "surplus" form, that is purely limited to functional objects and useful signs? True madness lies that way. Magic (in shamanic societies) and art (in societies that have validated the existence of artists) both belong to the domain of *symbolic efficiency*, through which human beings gain access to systems of references that allow them to integrate the contradictions and enigmas of the world in which they are immersed.

Before discussing the practices that constitute them into different disciplines or distinguishing Western art from magic, we must establish a preliminary: this comparison is, first and foremost, a matter of *topology*. Contemporary art and shamanism can be related only if they belong to a same topological space and are assigned structurally comparable positions in the chain of social functions. What anthropological concept can this comparison be based on? First, the joint appearance of ritual and art in the Upper Paleolithic period, which indicates their common origin and their role in the constitution of a symbolic culture among homo sapiens. It is possible that this double emergence responded to an embryonic division of labor, along with the visual development of a primitive notion of *territory*, or the use of images as pedagogical tools. The artists of Lascaux, Alain Testart writes, "must have been all at once religious officiants, ceremonial leaders, medicine men or something along those lines."[92] From the outset, art and magic form a parallel, but contiguous space, a space-time that compensates, corrects, or orients social organization; namely, the attitude of human groups toward nature. "Self-domestication through language, ritual, and art inspired the taming of plants and animals that followed," John Zerzan writes.[93] Following the lead of the division of labor that was amplified during the Neolithic Age with agriculture and animal husbandry, art and magic took separate roads. Meditating on

[92] Alain Testart, *Art et religion de Chauvet à Lascaux* (Paris: Gallimard, 2016), 271.

[93] John Zerzan, "Future Primitive," February 11, 2009, *Anarchist Library*, https://theanarchistlibrary.org/library/john-zerzan-future-primitive.

these common origins and wondering about the contrasted fates of magicians and artists in the West, Lévi-Strauss unearthed a notion recorded by the first ethnologist of the Melanesian peoples, but that circulated in various civilizations. This concept is mana.

It has many local variants, but it is defined as "a fluid that the shaman controls, which can cover objects in an observable form, which provokes displacements and levitations, and which is generally considered harmful in its effects."[94] This fluid element is therefore neither a type of object, nor a ritual, no more than it can be reduced to a class of people or a particular belief. It covers such-or-such an object, but it can be recognized because it exists "in an observable form." It provokes "displacements": a same object can thus be perceived differently if it becomes mana. Finally, it is feared because it is "harmful": it is perceived as an active agent, which one must respect and keep away from. In short, mana is at once a certain mode of action, a quality of objects, and a state. The similarity with what Western societies call art is striking: especially since, again according to Lévi-Strauss, the concept of mana designates "a universal and permanent form of thought, which, far from characterizing certain civilizations, or archaic or semi-archaic so-called 'stages' in the evolution of the human mind, might be a function of a certain way that the mind situates itself in the presence of things."[95] Knowing that it finds itself in the presence of art, our mind reconfigures itself: it recognizes, before anything else, a *situation*. In Melanesian society, mana represents exactly what art signifies in ours: a "floating signifier," a sort of additional regime of meaning, collecting in a specific mental zone the "surplus of signification" produced by a society. When Duchamp exhibited a bottle rack in an art gallery, he produced, within the social context of his time, a *special effect* comparable to that of a sorcerer: he endows an everyday object with a specific status by putting his name to it, just as a sorcerer will endow another object with his power. But only a collective consensus, even partial, can legitimize the value of the artist's work or the power of a sorcerer. The difference being that the latter's community endowed him with that power,

[94] Lévi-Straus, *Introduction to the Work of Marcel Mauss*, 52.

[95] Lévi-Strauss, 53.

while the artistic avant-garde had to fight for recognition in a climate of antagonism that endures to this day. So art and magic are *situations*. A Zuni sorcerer from New Mexico declares he can turn into a cat, or designates a feather as being endowed with enormous power; in the iconography of shamans and sorcerers, sculpted figures can be found alongside the fumes of burning cocoa beans (by the Cuna Indians). Magic does not reside in a class of objects, but in designated spaces and specific behaviors, exactly like the art of our time.

Exploring the prohibitions and *taboos* of primitive religions, the anthropologist Mary Douglas linked the symbolic structures of societies to their conception of *pollution* and hygiene. Prohibitions, dietary rules, and ablutions are common to every religious system, and their "ritual avoidances" are strangely reminiscent of the protocols for avoiding contagious diseases. "The sacred must always be treated as contagious because relations with it are bound to be expressed by rituals of separation and demarcation and by beliefs in the danger of crossing forbidden boundaries."[96] uncleanliness does not exist in itself; it "expresses a system." What is perceived as *unclean* disrupts the smooth run of things or introduces confusion, like fish without scales in the Hebraic religion. If we want to perpetuate the order of the world as it is, we must eliminate or avoid being soiled by what is excluded. Linking the sacred and the unclean, Douglas put forward a radical definition of pollution: it is *everything that is not in the right place*. Here, we circle back to the polarity between art and waste, since the definition covers both—the work of art is never in the "right place" either and it disorganizes the order of things. The artist sets his or herself the task of *displacing* constitutive elements of the world, of presenting them or representing them where we don't expect them. Douglas hinted at the idea by quoting Anton Ehrenzweig, who "argued that we enjoy works of art because they enable us to go behind the explicit structures of our normal experience."[97] A bottle holder in an art gallery (Duchamp), the flagellation of Christ under Tuscan arcades (Piero della Francesca), or a huge rock floating in

[96] Mary Douglas, *Purity and Danger: An Analysis of the Concepts of Pollution and Taboo* (London: Routledge, 1966), 22.

[97] Anton Ehrenzweig, quoted in Douglas, 38.

the sky (René Magritte) are figures of displacement connecting the two poles of art and uncleanness, the sublime and trash, in the space of floating signifiers, of "surplus of signification." The symbolic place of art is there, among unclassifiable and displaced things: it is the north of a compass whose south would be waste.

However, it would be absurd to assert that contemporary artists are shamans or sorcerers. What I am pointing out here is a structural analogy between the position of the former within their community, and of the latter in ours. To take an example, television has not "replaced" evenings by the fireside, neither in terms of contents nor of technology, but it has played a structurally similar role since the 1950s. And the analogies between art and magic, beyond the folklore of clairvoyance largely exploited by the Surrealists in their time, are convincing provided they are relocated within their respective contexts—our hypothesis being that the former has come to translate the values and the principles of the latter into a reflective, critical lexicon that allowed them to survive in Western societies. But the shift from magic to art, which comprises various degrees, rests on the survival of a space where Lévi-Strauss's surplus of signification can exist. In addition, contemporary artistic practices do not occupy the entirety of the social zone once reserved for magic. Indeed, Western societies have systematically tried to shoehorn their supreme value, monetary value, into it. Thus, art and commodity coexist, merging or fighting for the control of the surplus of signification of the collective unconscious. But monetary value, Anselm Jappe explains, "is the only fetishist form that is pure form without content, form indifferent to all content." Because it rests on the sacralization of the commodity, the pillar of its system, the society of productivist capitalism is fetishist. As Jappe argues, "Every fetishist society is a society whose members follow rules that are the unconscious result of their own actions, but that present themselves as powers exterior and superior to men, and where the subject is only the executant of fetishist laws."[98] We can therefore say that the place occupied by mana in precapitalist societies was "colonized" by an abstract value-form, just as

[98] Anselm Jappe, *La société autophage: Capitalisme, démesure et autodestruction* (Paris: Éditions La Découverte, 2017), 23.

money has replaced every other value. At the core of the capitalist system, we find a "pseudo-mana" void of meaning and indifferent to every content (monetary value), opposed by the mana embodied by contemporary-art practices. This concept sheds light on the theory of the "spectral dance" developed by Karl Marx in *Capital*, which shows the inversion of the relations between the human being and the product of his labor: "From the standpoint of market logic, commodities are self-sufficient. They are the true agents of social life. Humans only enter the scene as servants to their own products. Since commodities cannot walk, they assign to humans the task of moving them." With this image of a spectral dance, Marx perfectly described pseudo-mana, a magic effect "void of content" that dislodged archaic magic from the space it occupied in precapitalist societies.

As an artist, Joseph Beuys was identified as a modern shaman, a comparison that has been widely acknowledged. But what is it based on? The term itself is inappropriate: derived from the Siberian *shaman*, it was later used "to designate any individual who, in the interest of the community, traffics with the spirits or is possessed by them."[99] Shamanism does not exist: the word, as the first anthropologists stipulate, "does not designate a set of beliefs [...] but merely asserts the existence of a certain sort of men playing a religion and social role."[100] The role of the shaman, or of his counterparts, consists in negotiating with invisible forces to restore an order disrupted by some event. Basically, what does he do? Interceding with the animal realm and spirits, traveling to other worlds, he takes on disguises, organizes moments during which social principles are upended, uses psychoactive drugs, and pretends to be able to metamorphose or to transform matter by looking at it. Like a jester, he may bring to light what the social body restrains or represses. In the case of the Ndembu in Central Africa, he can also call on and listen to the people in order to identify the source of a problem. As many methods and figures that can easily be found in the work of today's artists. But shamanism rests on a consensus;[101] it is

[99] Alfred Métraux (1944), quoted in Jeremy Narby and Francis Huxley, *Anthologie du chamanisme*, trans. Pauline Troya (Paris: Albin Michel, 2018), 111.

[100] Arnold van Gennep (1903), quoted in Narby and Huxley, 63.

the emanation of social systems that the West has relent-
lessly worked to dismantle. The partial consensus enjoyed
by art enables it to replace the functions of shamanism,
position for position, but only in part. It is the West that
has compelled the whole world to follow a formal principle
that freezes up the energies required for magic: according
to this principle, nature is nothing more than a molecular
reservoir and scientific causality is the only one that exists.
Whereas for Marcel Mauss, magic is above all a "gigantic
variation on the principle of causality," the subversion of
physics by narration. It extends our chains of significations
to beasts and spirits, the sun and the wind, rather than re-
stricting them to cold scientific reason. By de-poeticizing
the world, capitalist Europe has dried up the well of inter-
species relations, dried up any negotiation with the world,
and then attempted to position monetary value in place of
mana. It has invented dry fetishism.

For a long time, magic managed human relations
by connecting evil to a person's circle (Who means you
harm?), or to the animal and vegetal world. In Bantu lan-
guage groups, in Africa then Brazil, the sorcerer (*nganga*)
in charge of controlling unbalanced forces puts on, during
ceremonies, a costume that combines the three realms:
stones, hair, and leaves. Every shamanic activity, Viveiros
de Castro explains, "consists in establishing correlations
and/or translations between the respective worlds of each
natural species" by seeking out similarities between points
of view, by creating beneficial fluxes between humans and
nonhumans. In this, shamans play the role of "cosmopolit-
ical diplomats [...] 'commuters' or conductors of perspec-
tive."[102] But it would be simplistic to oppose science and
poetry, or reason and magic. The most recent advances in
medicine or quantum physics, moving beyond the colonial
fracture, are operating new connections between ancestral
knowledge and the Western technostructure. Thus, Jeremy
Narby perceives Amazonian shamans as "readers of DNA,"

[101] As we have seen, the term is inappropriate—here,
it serves to designate any activity of intercession
performed by an *angakkut*, a shaman, a *piayé*,
a *page* ... as many names given in various societies
to the person in charge of the symbolic power of
communicating with the spiritual world.

[102] Viveiros de Castro, *Cannibal Metaphysics*, 152, 151.

deciphering the vital principle that unifies all forms of life. Through different techniques, they "gain access to information related to DNA, which they call 'animate essences' or 'spirits.'"[103] Their task is to *translate*: "Nature talks in signs and, to understand its language, one has to pay attention to similarities in form. [...] The spirits of nature communicate with human beings in hallucinations and dreams—in other words, in mental images."[104]

Narby stresses the role of dreams in this communication with the world of spirits. Is it by chance that the status of dreams, and the fact that society took them serious, changed in Europe with the great confinement? Oneiric activity lost its importance as of the seventeenth century, severed from the sphere of magic that gave meaning to its imagery. Dreaming is one of the pillars of shamanic journeys, and its exclusion from the social field is just as revealing of the mental police that settled in Western countries, a police whose sole purpose was to rationalize production, and who conceived of dreams as unproductive and potentially dangerous. Worse still, the dreamer escapes into an alternate world, leading to introspection and therefore conducive to a critical mind. For Eduardo Kohn, beyond its shamanistic function, the act of dreaming is a sort of *pensée sauvage*:[105] "It is a form of thinking unfettered from its own intentions and therefore susceptible to the play of forms in which it has become immersed."[106] Marginalized in capitalist civilization, this *formal* mode of thinking would only regain its central role with Surrealism, when artists and writers explored non-Western thought, and when art invaded the space of the "surplus of signification" that Lévi-Strauss spoke of. In *Communicating Vessels* (1934), André Breton saw dreams as a "natural necessity" and sought to rehabilitate them as mental models: based on nighttime visions, poetry strives to break down the binary structures that structure the industrial world (dream and reality, the

[103] Jeremy Narby, *The Cosmic Serpent: DNA and the Origins of Knowledge* (New York: Jeremy P. Tarcher/Putnam, 1998), 136.

[104] Narby, 96–97.

[105] Translator's note: In French in the original.

[106] Kohn, *How Forests Think*, 188.

possible and the impossible, necessity and chance ...). The artist allows him or herself to work as a shaman in his or her milieu, that is, to seize all available signifiers: Surrealism, defined by Breton as "the dictation of thought, free from any control by the reason and of any aesthetic or moral preoccupation," reconnects Western artistic practice with the world of magic, not by telling stories of the supernatural or by spreading a belief, but by reconnecting the artist with his or her milieu. Like shamanism, art can become a field where objects, forms, or images are removed from the sphere of usefulness, considered for their *signifying* value and their capacity to materialize relations with the world.

Anthropology distinguishes two types of shaman, corresponding to two distinct social models: one works within his community in a *transversal* way; the other places himself on a *vertical* plane. Historically, and with reference to the American continent, the appearance of the latter corresponds to the state's capture of shamanism in Andean societies, who adapted it to the hierarchical city. The shaman became a priest, a sort of spiritual engineer, a guardian of traditions: he exercised a sacerdotal function, like European prelates. In "stateless" societies, the Amazonian shaman had an entirely different social role. Both doctor and warrior, he had knowledge that was experimental and essentially empirical; his function within the community was prophetic and disruptive. Though they may seem to succeed each other in time, these two figures, who actually emerged from different societal choices, can be used as structural explanations for the history of art, if we apply, term by term, the oppositions between these two figures of intercession. On the one hand, the shaman was as healer, DIYer, jester, who exercised a prophetic function. On the other, the priest-engineer exercised a sacerdotal function for the state. Since the great confinement of the Classical Age, artists followed exactly the same path: it would be reversed with the figure of the modern artist who, like the original shaman, resorted to bricolage and experimentation, bore a "prophetic" discourse called avant-garde, and opposed the social consensus represented by *official artists*.

But let's get back to the common space where art and magic succeed one another and intermingle throughout the history of humanity, the space where things are not in their place. The space where, in Lévi-Strauss's view, the "signifier-surfeit" with which the human being is confronted

(*all that I see should have a meaning, but I don't quite know
what it is, nor what to say it with*) faces forms "to which it
can be fitted."[107] This space is where shamans and story-
tellers in their milieu, just like artists today, select combi-
nations from a repertoire of available positions (mythical or
aesthetic) and elements (material or intellectual). In short,
artistic creation is a bricolage comprised of a finite num-
ber of forms, formats, and colors. It should be noted that
the allusion to a limited number of possible combinations,
which echoes Paul Valéry's "finite world," implicitly contra-
dicts Western mythology, which narrates art as a logical
evolution, a series of "progressions" based on the idea of
the "new." This mythical narrative reaches its apex with
the invention of perspective, the modernist return to flat
surfaces, and the "discovery" of abstraction ... The truth
seems to be both more prosaic and more universal: each
artist combines and reorganizes figures and materials that
exist in limited quantities, according to what he or she finds
in the space where the play of significations is elaborated
within his or her community. So depending on what he or
she can find. But also, according to his or her position as an
individual in relation to this collective baggage. Therefore,
art does not *progress*, it keeps rearticulating itself and is a
kaleidoscope of ideas and forms; it is an infinite dialogue
between the human being and his or her milieu. Joseph
Beuys joins Marcel Duchamp in defining the artist as *a car-
rier of the unknown*. As will be discussed in the following
chapter, artists today are reconnecting with ancient modes
of thinking by exploring the molecular world, the emissions
of the industrial world, and the objects that surround them.

[107] Levi-Strauss, *Introduction to the Work of Marcel
Mauss*, 62.

The Artist as
Molecular Anthropologist

*We must first of all draw up as large as possible
a catalogue of categories, beginning with all those
which it can be discovered that mankind has ever
employed. It will then be seen that there have been,
and that there still are, many dead moons, and
others pale or obscure, in the firmament of reason.*
Marcel Mauss

AN INTEGRAL RELATIONAL AESTHETIC, OR THE PULVERIZED ANTHROPOLOGIST

> *Form in art is distinguished by the fact that,*
> *opening up new contents, it develops new forms.*
> Walter Benjamin

Before it became a fully fledged science, anthropology existed in *nucleo* in the observations of European explorers, missionaries, and colonists, in the rudimentary form of a discourse on the *elsewhere*. Marco Polo and Michel de Montaigne represent the two poles from which the elsewhere evolved: on one side, a narrative, and on the other, a reflection on the customs and behaviors of exotic societies. In the thirteenth-century travelogue of Asia, *The Travels of Marco Polo* (ca. 1300), the Venetian merchant Marco Polo listed the spices and gems he saw and described his experiences at the court of the Mongol emperor Kublai Khan. Montaigne, on the other hand—with the exception of the journal of his voyages in Italy—collected accounts of explorers and met the first "natives" brought to France. Drawing from this information, he wrote the essay "Of Cannibals" (ca. 1580), a plea for cultural relativism and a critique of Western intolerance, summed up by his famous formula: "Each calls barbaric that to which they are not accustomed." In "An Apology for Raymond Sebond," the lengthiest of his essays, Montaigne extends his line of reasoning by launching into a genuine anti-speciesist manifesto, which takes on a particular resonance in the Anthropocene. Establishing the list of so-called specificities of the human being and comparing it to animal behavior, Montaigne meticulously destroys any pretense that the human being is an exception, urging us to think about the world by including other species: "Most of the arts we have were taught us by other animals, as the spider has taught us to weave and sew, the swallow to build, the swan and nightingale music, and several animals, in imitating them, to make medicines."[1]

For the human being to become, for the first time, the object of specific studies, after being the all-powerful subject of knowledge, a new mental partition needed to be drawn through the division of the world between colonists

[1] Montaigne, "Apologie de Raymond Sebond," in *Les essais* (Paris: Éditions Arléa, 1992), 317.

and the colonized—a separation that occurs, as it happens, during Montaigne's lifetime. Social life could become the object of a specific science because some human beings were suddenly considered *specimens* and objects of *commerce*, just like the plants Humboldt brought back from his journeys or rhinoceroses that could be preserved thanks to the invention of taxidermy. Thus, anthropology was based on an ideological program: identifying colonization with the progress of humanity. It therefore follows that the objects of its studies were not considered *contemporaries*. For what was still called ethnology, a Bororo Indian or a member of the Kwakiutl nation belonged to the past of humanity, while the Western anthropologist came from a future they had to accept. Thus, the ethnologist posited that the "primitive" or "savage" belonged to another period in history, located at an inferior level on the timeline—*the childhood of humanity*, as it was said then. Jean-Jacques Rousseau's "noble savage," conceived in pre-ethnological times, was quickly followed by the "primitive": and if the former was the idealized concept of uncivilized man by European thinkers, the latter was seen as simply backward. We find the purest expression of this evolutionist theory in a classic of the nascent science of anthropology, *The Golden Bough* (1890) by James George Frazer, who saw magic as a "a ruder and earlier phase of the human mind, through which all the races of mankind have passed or are passing on their way to religion and science."[2] Before reestablishing itself as the study of all human societies, anthropology was originally presented as a time machine, just like astronomy observing stars that disappeared thousands of years ago. In its beginnings, and probably until Lévi-Strauss, anthropology was just a kind of social astronomy, the study of faraway cosmic phenomena being comparable to that of human diversity in a discourse oriented by *progress*. It was considered an archaeology of Western society, what it called history, being summed up by the product of a technological and military big bang that started in Athens and Rome. This "denial of coevalness," to reprise the expression coined by the German anthropologist Johannes Fabian,[3] allows us to understand why *progress*, the other name of

[2] James George Frazer, quoted in François Laplantine, *L'anthropologie* (Paris: Éditions Payot & Rivages, 1987), 64.

the Westernization of the world, was based on the denial of the Other. Before becoming a science that allows us today to dissolve the notions of nature and culture within the same reflection, anthropology was used as a scientific auxiliary in a police operation based on the hierarchy of beings, of which nature was on the lowest level.

Before showing how it ended up including the anthropologist himself, "decolonizing" itself by giving up its ethnocentrism, then going beyond the sole study of human beings, let us emphasize the fact that, if there is a field of Western knowledge that articulates our relation to the *Other*, it is indeed anthropology. Tim Ingold defines it nicely as a "philosophy with the people in it." A participative science, it consists of "learning *with* and learning *from*: it opens up a life process that engages a transformation of the process itself."[4] In other words, there is no observation without participation, dislocating the subject/object relation that was once consubstantial to all science. Anthropology is simultaneously inside and outside the reality with which it engages—and this is why it has no objects, but rather *interlocutors*: the knowledge it generates arises from a relation of correspondence with the world, in the dialogic sense of the term. It is even widely accepted among anthropologists that they must include themselves physically and subjectively in their research: "What the researcher experiences, in his relation to his interlocutors (what he represses or sublimates, what he detests or cherishes), is an integral part of his research."[5]

The great issue anthropologists and artists have in common is fine-tuning the right *distance* from their interlocutor (from reality as a whole), so they can produce knowledge, rather than reproduce what is *already known*. And if the practices of the former and latter are called into question today by the Capitalocene, it is because of the huge topological intermingling it has induced:

[3] Johannes Fabian, *Time and the Other: How Anthropology Makes Its Object* (New York: Columbia University Press, 2014).

[4] Tim Ingold, *Faire: Anthropologie, archéologie, art et architecture*, trans. Hervé Gosselin and Hicham-Stéphane Afeissa (Paris: Éditions Dehors, 2018), 25.

[5] Laplantine, *L'anthropologie*, 169.

the disappearance of the notion of *faraway*, immediate communication, the uniformization of the world, species living closer to each other. Claude Lévi-Strauss, when asked if knowledge depended on the distance between the subject and the object, answered: "It is an aspect. In a second phase, we will try to make them meet. There would be no possible knowledge if we didn't distinguish between the two moments; but the originality of ethnographic research consists in this constant to-and-fro."[6] As it happens, contemporary humanity's shortage of the faraway coincides with an industrialization of travel that has made the exotic commonplace. In fact, we all practice ethnology daily: our contact with the elsewhere occurs through social networks—a far cry from the explorer missioned by an institute and equipped with expertise. The aura of the first ethnographic photographs, arising from an exceptional contact with exoticism, has given way to a permanent feeling of strangeness, fed by an iconographic explosion.

The artist and the anthropologist can be compared through their constant to-ing and fro-ing from the field to the studio, from reality to its shaping. They share many principles and methods. According to Lévi-Strauss, the work of the anthropologist consists of "putting himself in the place of the men living there, to understand the principle and pattern of their intentions, and to perceive a period or a culture as a significant set."[7] For Philippe Descola, "an anthropologist is someone who reflects on the formal properties of social life."[8] The ambition to *give shape* to the world through diligent observation, the *empathetic method* that characterizes them both, makes anthropology an art of otherness—and contemporary art a pulverized anthropology, oriented toward visual systems. The artist and anthropologist are emphatic, because the relational predominates in the discourse of both, but it is a *heuristic* empathy since they, with their respective tools, are meant to generate knowledge. The difference between the two

[6] Claude Lévi-Strauss and Didier Eribon, *De près ou de loin, entretiens: Suivi d'un entretien inédit "Deux ans après"* (Paris: Seuil, 1991), 215.

[7] Lévi-Strauss, *The Savage Mind*, 250.

[8] Philippe Descola, *Une écologie des relations* (Paris: CNRS Éditions, 2019), 5.

practices is expressed by the words of Mark Leckey, which were quoted earlier: "You can talk about, or rather involve yourself with objects, without continuous recourse to concepts and critique. Not only approaching them as though they are only organized by language, by us. You can try and empathize with them on a whole other level."[9] Two levels of understanding of the world are linked by what nineteenth-century painters used to call "painting from nature." Even if they destabilized by their observations, the encounter with a distant society can call into question the certainties of the anthropologist, and the confrontation with a subject of study changes the approach of an artist. There are many accounts of disastrous experiences on the field: *Tristes Tropiques* (1961) is an account of Lévi-Strauss's failure to contact the Indians of Tibagy, who were decimated by tuberculosis and alcoholism; Nigel Barley has described, in an almost comical manner, how he was constantly manipulated by the tribe he had come to study, the Dowayo of Cameroon.[10]

One evening in 1951, in Chicago, the artist and sculptor Tony Smith offered three of his students from Cooper Union a ride back to Manhattan. On the way, he took a chance by taking New Jersey Turnpike, a freeway that had just been completed but was still without white lines, lights, or guardrails. Smith could only count on his headlights: "The road and much of the landscape was artificial, and yet it couldn't be called a work of art. On the other hand, it did something for me that art had never done. At first I didn't know what it was, but its effect was to liberate me from many of the views I had about art. It seemed that there had been a reality there that had not had any expression in art."[11] Fascinated by the sight of various knolls and the industrial architecture that lined the freeway, punctuated by smoke and colored lights, Smith found a new relation to space that would lead, a few years later, to the birth of

[9] Leckey, "Techno-animism."

[10] Nigel Barley, *The Innocent Anthropologist* (Long Grove, IL: Waveland Press, 1983).

[11] Tony Smith, quoted in David Salomon, "The Highway Not Taken: Tony Smith and the Suburban Sublime," September 2013, Places, https://placesjournal.org/article/the-highway-not-taken-tony-smith-and-the-suburban-sublime/.

Minimal art. But this is also the story of the first symbolic conjunction between the suburban environment and the avant-garde. The highway by night, at full speed, like those we see in David Lynch's films, could well be the primal scene of American contemporary art. The entanglement of human industry and nature, whose seminal locus would be a highway ripping open a landscape, was experienced during the postwar years as a source of awe and inspiration. We find it in Ed Ruscha's 1963 artist book, *Twentysix Gasoline Stations*, frontal pictures of these strange buildings by the highway, in a sort of topographical survey evoking the views seen in travel brochures. In the 1950s, Bernd and Hilla Becher photographed, with the same objectivity, according to an immutable protocol, the industrial architecture of the Ruhr region in Germany. But what is less apparent in this neo-documentary aesthetic is its surrealist aspect, the introduction of the *uncanny* inherent to these industrial grafts on nature. We find traces of it in the work of Robert Smithson, who also explored New Jersey looking for what he called "ruins in reverse." The Minimal art of the 1960s, and even more so its later expressions, would also be an industrial and suburban surrealism, as much as documentary art contributing to an anthropology of Homo industrialis. In the 1980s, David Robbins saw in the appearance of residential suburbs in the United States a mental paradigm he described as a "suburbanization of imagination." Neither city nor countryside, American suburbs are a space where trees and traffic coexist, generating an in-between imaginary, opposing to the established categories of high culture objects belonging to both worlds.[12]

Direct contact with the uncanny, with absolute otherness, belongs to art as much as it does to anthropology, though they don't use it in the same way. For the philosopher Patrice Maniglier, anthropology is defined by "the decision to admit no other instrument for the production of knowledge than the capacity of the subject of science himself to embrace ways of thinking, of feeling and acting which seem a priori unacceptable to this subject."[13] In other words, it is when you don't understand something that you start to know it, and the presence of absolute

alterity is the very condition of anthropological thought. The *other* that the anthropologist questions is not simply there to be deciphered like an enigma, but to contribute to our knowledge of the human being in his or her milieu. In Maniglier's words, "otherness is not the object of anthropology, it is its instrument." And if it had an ontological premise, it could be summed up by the formula: "being, is being able to be other."[14] Art and anthropology are based on a transformist and dialogic ethics: becoming what you depict, inhabiting what you see, moving among the most radical otherness. In his review of *Tristes Tropiques*, Georges Bataille admits he is "fascinated" by Lévi-Strauss's "embrace of an immediate openness to any kind of thought that presents itself."[15] These exercises in decalcification would yield a thinking of absolute relativism, and a method that "consists simply in not taking the values and institutions of the observer as a model to calibrate the values and institutions of the observed," in the words of Descola.[16] Early on, Bataille had guessed that "ethnography is not merely a field of knowledge among others, it is the questioning of the civilization of knowledge, which is the civilization of ethnographers."[17] The development of anthropology was the development of acculturation as seen in a mirror, a psychoanalytical process where transference and countertransference constantly succeed one another in the blurry reflections of the collective unconscious. One of the first to shift his frame of reference outside the Western position of authority was Marcel Mauss in his essay "The Gift," in which he used local concepts (potlatch, *hau*) instead of overlaying exogenous notions on the lives of the peoples in question. It was a genuine breakthrough at a time when the bases

[13] Patrice Maniglier, "La vérité des autres: Discours de la méthode comparée," in *Choses en soi: Métaphysique du réalisme*, ed. Emmanuel Alloa and Elie During (Paris: Presses universitaires de France, 2008), 468.

[14] Maniglier, 477.

[15] Georges Bataille, "Un livre humain, un grand livre," in *Oeuvres complètes*, bk. 12 (Paris: Gallimard, 1988), 384.

[16] Philippe Descola, *La composition des mondes* (Paris: Champs Essais, 2014), 243.

[17] Bataille, "Un livre humain," 382.

of ethnology were being laid "to tackle an ethnographic problem from the standpoint of its New-Zealander or Melanesian theory, rather than through western notions such as animism, myth or participation."[18]

Joseph Kosuth wrote *The Artist as Anthropologist* (1975) after studying philosophy and anthropology with Stanley Diamond at New York's New School for Social Research in the early 1970s.[19] In this text, whose purpose was to define his own artistic practice, he distances himself from exoticism: for Kosuth, arriving in an unfamiliar society and bringing back information to be translated into the codes of one's own culture is not a productive model for art. Researching language, the pioneer of Conceptual art thought that the artist could be compared to an "engaged" anthropologist, who, instead of being "fluent" in the culture of others, must exclusively address his own. "The artist, as anthropologist, is operating within the same socio-cultural context from which he evolved. He is totally immersed, and has a social impact."[20] Kosuth's argument involved a critique of what he called the "Scientism" of twentieth century art, which stems from the Western habit of *looking at reality from the outside*. Instead, the artist must be part of the reality he or she observes, immersed in the world he or she describes. Therefore, according to Kosuth, you can only be the anthropologist of your own biotope. But this praise of ethnographic "praxis" hides an attack against the artistic practices of his time, too focused on the "depiction" of culture, and in doing so, remaining abstract and static, based not on experience but on "abstractions of experience." Kosuth wrote: "It is in this sense that one can speak of our civilization as being out of control, having a will of its own, being an automated system. [...] We [...] live in a totally enculturated world which is running out of control precisely because it does operate independent of nature."[21]

[18] Lévi-Strauss, *Introduction to the Work of Marcel Mauss*, 41.

[19] Joseph Kosuth, "The Artist as Anthropologist," *The Fox* 1, no. 1 (1975): 18–30, http://www.darkmatterarchives.net/wp-content/uploads/2012/09/The-Fox-1-1975.pdf.

[20] Kosuth, 24, 26.

[21] Kosuth, 28.

In *The Artist as Ethnographer?* (1996), Hal Foster took an opposing view. While Kosuth insisted on the need to adapt anthropological methods "within the same socio-cultural context from which he [the artist] evolved," Foster, who only quotes the artist in a footnote, instead asserts that "it is now the cultural and/or ethnic other in whose name the artist often struggles." With this, he indicates a paradigm shift, by commenting on the works of a generation for whom the *elsewhere* and the *outside* have become "the Archimedean point from which the dominant culture will be transformed or at least *subverted*."[22] Foster prefers to speak of "quasi-anthropological art" about the works he comments, namely, those of Lothar Baumgarten, who spent a lengthy period in the Amazon in the 1970s, Mary Kelly who organizes a polyphony of images and voices around her personal experience of motherhood, and Allan Sekula and his cartographies of industrial production. But it is the following generation of artists that would use cultural studies as a method and impose the image of the artist as a "self-aware reader of *culture understood as text*," therefore justifying the parallel with ethnography.[23] It must be remembered that cultural studies were founded on a basic anthropological principle: the non-hierarchization of information sources. Just as Bronisław Malinowski deduced the social organization and the belief system of the people of the Trobriand Islands from the shapes of their canoes, cultural studies focus on objects that are neglected or considered futile, as do many contemporary artists. The principle of *investigating* from slender clues was a necessity for the ethnologist confronted with "societies without writing" and forced, for want of written records, to analyze material or visual cultures. It was the scarceness of available indications that gradually drove anthropology to make the unconscious of the societies they studied speak, to summon the objects and traces that constitute the basic materials of so many artists today, and in doing so, to modify the entire cognitive structure of the West.

[22] Hal Foster, "The Artist as Ethnographer,"
in *The Return of the Real: The Avant-Garde at the End of the Century* (Cambridge, MA: MIT Press, 1995), 173 (emphasis in original).

[23] Foster, 180 (emphasis in original).

More specifically, the artists mentioned by Foster combine the model of cultural studies with postcolonial thought and feminism, practicing a cultural anthropology of the segregations created by the visual system of museums. Granted, these artists could be taken to task, in Kosuth's terms, for preferring "abstractions of experience" to experience itself, but what kind of experience do postindustrial societies offer, if not those mediatized by institutions and the market? However, Foster is wary of the ethnographic model, underlining the risk of a kind of ideological paternalism, or of idealizing "the anthropologist remade as an artistic interpreter of the cultural text" that would turn it into a mere "compromise discourse."[24] It must be said that artists find multiple echoes of their own practice in those of "ethnographers," as Foster calls them: anthropology is a science of otherness, whose object is culture; it pays particular attention to context; it is both interdisciplinary and self-critical. So many points in common with the artistic practices that appeared in the 1990s. A few years later, Okwui Enwezor would revisit the theme of ethnology through his own African identity for the 2012 Paris Triennial, "Intense Proximity," which sought "to examine and confront the dialectics at play between the social facts that ethnographic realism seeks to unravel, and the speculative forms produced by contemporary art."[25]

As far as methods go, there are indeed few differences between a work by Mark Dion and one of Tim Ingold's "pedagogical experiments." For *An Archeology of Lost Objects* (2013), Dion organized a collection of urban trash from the streets of Madrid, which he then archived and displayed in wooden cabinets designed for the occasion. Seeing anthropology as an "art of investigation," Ingold proceeded in an identical way by asking his students to collect a selection of found objects. There were coins, paper clips, rubber balls, seagull feathers ... "We were staring at this heap when a spider crawled out to cross the rug. It had arrived as a stowaway with one of the objects,

[24] Foster, 180, 183.

[25] Okwui Enwezor, *Intense proximité: Une anthologie du proche et du lointain*, exhibition catalogue (Paris: ArtLys, 2012), 23.

[26] Ingold, *Faire*, 53–58.

no one knew which. But was it part of the object?"[26]
The artist, like the anthropologist, tries to make the world speak, but he or she has no need to translate the elements that compose it into a foreign language. The artist is a formal polyglot, and Ingold's spider pops up again, this time as a guest, in Tomás Saraceno's installations. Since the publication of the theoretical texts quoted above, the anthropological model has widely exceeded the boundaries of its classical framework. Bolstered by the theories of a new generation of anthropologists who reject the separation between nature and culture, as well as the feeling of superiority Western societies have over the people they study, art now embraces, within this anthropological perspective, extra-European modes of thinking and doing, but also the ensemble of nonhumans.

 This excursion outside the human sphere is the outcome of a logical evolution. Indeed, we must remember that when it emerged in the late nineteenth century, anthropology marked the decentering of the human being, who went from being the *subject of knowledge* to being an *object of study*, like nature. And subsequently, it continued filling the gap between the two positions: the Western researcher became less and less of an *omniscient subject* (a "subject supposed to know," as Lacan would say), turning into an object among others in an ever-broadening landscape. And though the disappearance of truly autarchic "primitive societies" in the second half of the twentieth century could have diluted anthropology into a kind of comparative sociology, anthropologists took advantage of the opportunity to feed from indigenous modes of thought and invent a comparative philosophy of multiple otherness, focusing on the relations between all the elements that compose the world. We can thus consider the study of primitive societies as the laboratory where Western thought started being undermined, namely, its core tenet—the metaphysical wall erected between nature and culture. The leap into the nonhuman arises from an encounter with otherness in the field: because he discovered that animals are considered "social partners" by the Achuar, Philippe Descola could call Western ontology into question. Owing to his stay with the Runa, Eduardo Kohn understands the forest as a source of *intentions* and *significations* that do not necessarily concern humans, but that should be interpreted in the same way as theirs, using theirs. Tobias Rees sums up the project

of this inclusive anthropology as starting from the composition of the world as it is and studying the way the human being has integrated within it. But he points out the danger that animals (or plants) "assume the role formerly reserved to 'the primitive': as a moralizer of the (Western, modern concept of the) human."[27] The danger would be turning the nonhuman into the new noble savage, in a new version of the humanization of the world, or even a universalization of the human species.

The fact remains that today a "multispecies anthropology" has emerged,[28] observing organisms whose life and death are connected to human activities. A remarkable example of this type of research is the book Anna Tsing dedicated to the matsutake mushroom, a case study on the relationships between humans and their environment, coupled with an overall view of the mechanisms of the global economy. This anthropology of the intermingling of beings, materials, and organisms dissects the complex strata that form the contemporary world. In the field of the history of sciences, Bruno Latour undertook a similar endeavor by highlighting the institutions, instruments, and multiple agents (human and nonhuman) that contributed to the discovery of bacteria by Louis Pasteur.[29] The main thrust of this reshaping of knowledge is the dissemination of the human subject into a network of agents that were, until then, either too hard to see or too massive to belong to our circle of interlocutors. From the virus to the ozone layer, new characters inhabit a world that no longer needs to invent gods to populate the invisible. The Capitalocene, let us insist, puts the human scale in crisis, disrupts our modes of representation, and broadens our relational cartography: in artistic representations, just as in anthropological studies, what now predominates is the *multifocal*, and relations take precedence over isolated objects. For the physicist

[27] Tobias Rees, *After Ethnos*
(Durham, NC: Duke University Press, 2018), 67.

[28] S. Eben Kirksey and Stefan Helmreich,
"The Emergence of Multispecies Ethnography,"
Cultural Anthropology 25, no. 4 (November 2010):
545–76.

[29] Bruno Latour, *Pasteur: Guerre et paix des microbes*
(1984; repr. Paris: La Découverte, 2001).

Karen Barad, whose research is based on the principles of quantum physics, there are no isolated objects that would then become agents of an interaction with other objects: everything that exists emerges from a relationship. Nothing is a simple "thing," there are only beings *doing*. Since beings are already connected, there are no interactions, but what Barad calls "intra-actions," the movements of a living reality that reconfigures itself permanently. Separation does exist—or rather, "agential cuts" arising from a *cutting apart*/*together* that produce temporary separations from which other individuals emerge.[30] To put it another way, we can quote Emanuele Coccia: "What we call nature is just a space of perpetual negotiation inside which species try, without necessarily succeeding, to cohabit. [...] Species, all species, are constantly changing the world, are constantly forced to dialogue and sign pacts with the others."[31] Negotiating, like the Amazonian shaman crossing worlds, identifying interlocutors, formalizing relations: multispecies anthropology is a relational aesthetics. In the field of art, objects only exist through the relations they generate. As Lévi-Strauss says: "It is not each object in itself that is a work of art, it is certain dispositions, certain arrangements, certain connections between objects. Exactly like the words of a language: by themselves, their meaning is very vague, almost empty, they only take on their meaning within a context."[32] In the same way, the notion of humanity has no meaning outside the relations that give it a content.

[30] Karen Barad, *Meeting the Universe Halfway: Quantum Physics and the Entanglement of Matter and Meaning* (Durham, NC: Duke University Press, 2007), 33.

[31] Emanuele Coccia, "Toutes les espèces sont constamment en train de changer le monde," *Magazine Littéraire*, March 2019, https://www.nouveau-magazine-litteraire.com/entretien-écologie/emanuele-coccia-«-toutes-les-espèces-sont-constamment-en-train-de-changer-le-monde.

[32] Claude Lévi-Strauss, in Georges Charbonnier, *Entretiens avec Lévi-Strauss* (Paris: Presses Pocket, 1992), 114.

THE MOLECULAR TURN

> *From the time when he first began to breathe and*
> *eat, to the invention of atomic and thermonucle-*
> *ar devices, [...] what else has man done except*
> *blithely break down billions of structures and re-*
> *duce them to a state in which they are no longer*
> *capable of integration?*
> Claude Lévi-Strauss

Any contemporary art discourse must be based on a pri-
mordial question, that of knowing *what* it is you are the
contemporary *of*. Or rather, of which *event* is it the exten-
sion in the universe of forms? We could also turn the ques-
tion around by looking at what the artists we find important
focused on. Édouard Manet attended to the industrial-
ization of the human gaze in the wake of the invention of
photography; Andy Warhol, the advent of the media age by
transforming individuals into infinitely repeatable pictures;
Joseph Beuys, the disconnection between human beings
and their milieu. And while the events that will durably mark
our times are not necessarily those we think, art is a sphere
through which we gain access to an immediate intelligibility
of the world. Artists practice a sort of social seismography
by capturing, through the forms they compose, what will
later crystallize into historical narratives. With regard to
major movements, we now see that Pop art responded to
the birth of mass consumption, that Minimal art seized the
industrial materials of its times (from anodized aluminum
to Plexiglas), and that Conceptual art anticipated both the
generalization of microprocessors and the bureaucratiza-
tion of the world. These passages between various suc-
cessive worlds of reference operate through overlaps, like
independent tectonic plates or sequences that respond
to one another. The artist of the early twenty-first century
is the contemporary of the Anthropocene; this does not
compel him or her in any way, but it determines his or her
vision. Today's artist is, therefore contemporary of 1) the
degradation process of ecosystems, 2) the extinction of
animal species, and 3) pandemics, from H1N1 to COVID-19.
What these three instances show is that a broader phe-
nomenon dominates our times: the double domination of
the tiny and of the gigantic on social life, the major role the
microscopic and the invisible play in world politics.

Glyphosate, carbon dioxide, tear gas, endocrine disruptors, droplets that contaminate: the true agent of history in the Capitalocene is the molecule. These natural elements we once perceived as "inanimate" are now feared, examined, and scrutinized as potentially dangerous agents. Quantum physics taught us that matter is not the mere receptacle of events but an *agent*, just like the human being, and that we cannot separate it from space or time. The invisible is now back in our daily life, in the form of a virus or of varying global temperatures.

A new generation of artists who emerged in the 2010s set out to perceive the world at this level of reality. Rather than focusing on objects, things, or products, they observe the molecular structure of social realities, the atomic relations that compose the illusory stability of the world. If the revelation of the social relations hidden within our relations to things was the major theme of Marxist thought, the Anthropocene has extended this reflection to the whole of the living, clearly showing that our relations to the "natural" world reflect the totality of social relations. The essence of capitalism resides in the appropriation of living organisms to commercial ends, from the creation of hybrid seeds to the private ownership of plants, water, or the subsoil. Things and beings tend to merge because exchange value has become the common denominator of all forms of existence—and the price tag, the most easily perceptible level of reality. It is therefore crucial to shift our gaze, to draw it toward the *molecular* level of reality (made up of dusts, fluids, etc.) by elaborating apparatuses that question this abstract order. Through collecting samples, assembling or fusing heterogenous materials, or analyzing matter, these artists question human societies by drawing our gaze to their physicochemical components. These *reduction* or pulverization processes aim to translate visible reality into particles and atoms: in doing so, they oppose the processes of capitalism, which reduces beings and things to a very different type of unit, monetary value. The artistic practices oriented toward the molecular aim to intensify reality by emphasizing the unique composition of each being or object. Only at this level can the connections between different "spheres" be shown, and the coherence of the living come to light. This global awareness fosters new artistic practices, arising from what we could call "molecular anthropology," whose project would be the

study of the human effects, traces, and imprints on the universe, and the interaction of humans with nonhumans.[33]

Behind the object or the product, today's artists observe the molecular structure of social realities, the atoms that compose social, political, or economic life. Alice Channer collects lumps of concrete from construction projects in London or mussel shells, then modifies and manipulates their nature and shape through various techniques to create a futuristic geology where the distinction between the organic and the artificial is abolished. Alisa Baremboym creates alloys within the very materials that compose her sculptures, incorporating ceramic, software, silicon, or complex gels into shapes evoking human prosthetics. Roger Hiorns turns airplane engines into piles of powder, Bianca Bondi chemically crystallizes everyday objects in glass cases, while Caroline Corbasson scans the dust of the Atamaca desert in Chile with a microscope. What all of these artists show are the chemical, invisible determinations that structure our social behaviors: Pamela Rosenkranz paints under the influence of Viagra, or introduces molecules or bacteria affecting perception in her exhibitions; Juliette Bonneviot incorporates within her sculptures particles of xenoestrogens, substances that mimic human hormones; Dora Budor, whose preferred material is dust, diffuses oxytocin, a brain-altering substance that apparently amplifies whatever social proclivities a person already possesses, whether positive or negative. Other artists systematize interspecies collaboration: Aude Pariset introduces an earthworm population in polystyrene blocks; Agnieszka Kurant puts millions of termites to work; Jared Madere designs attraction parks for bees and ants. These molecular artistic practices present a world where nature and culture have definitively merged.

The relation between mass and singularity is expressed, in the lexicon of physics, as an opposition between the molar and the molecular. As early as 1981, Félix Guattari discussed globalization (his term for it was "integrated world capitalism") from a chemical standpoint, calling for a "molecular revolution." In other words, a "molecular

[33] This chapter is a revised version of the text published in the catalogue that accompanied the exhibition "Crash Test: The Molecular Revolution," which took place at La Panacée – MO.CO, Montpellier, in 2018.

sabotage of the dominant social subjectivity" in which
the multiplication of interstitial struggles would replace
traditional political parties.[34] Guattari foresaw "a kind of
bacteriological social war, something that no longer asserts
itself according to clearly delimited fronts (class fronts,
protest movements), but rather in the form of less appre-
hensible molecular revolutions." To oppose the system
more efficiently, he wrote, we must downscale issues to a
molecular level and forego large molar masses, because
capitalism has already begun to "miniaturize its apparatus
of repression." According to Guattari, "All sorts of viruses
of this type are already attacking the relation of the social
body to consumption, work, leisure and culture (autoreduc-
tion, questioning work, the political representation system,
pirate radio). Mutations with unforeseeable outcomes will
constantly emerge within the conscious and unconscious
subjectivity of individuals and social groups."[35]

The Anthropocene leads us to extend to all exis-
tent beings the critical suspicion Marxism applied to prod-
ucts: social relations are now disseminated everywhere.
While we may feel as though we are wandering within a
huge landscape of commodities, these artists incite us to
explore the inner workings of life, to grasp material reality
before it is reduced into a commodity. As we've already
stated, the implicit program of capitalism consists in the
derealization of the world in order to ease the flow of mon-
ey, smoothing out its material asperities, turning everything
into a barcode. According to Walter Benjamin, the mission
of the materialist historian consists in uncloaking the *real*
that the capitalist program tries to erase, that is, to *wake
up*. It is an awakening that occurs as an irruption, an un-
veiling, a brutal emergence. "The real can only be unveiled
through the ruins of a semblance," explained Alain Badiou,
taking as an example the onstage death of Molière during
The Imaginary Invalid. In other words, the real can only
appear within a *dialectic*: both terms must be maintained,
the real and the semblance. Walter Benjamin spoke of the

[34] Félix Guattari, *La révolution moléculaire*
(Paris: Galilée, 1977).

[35] Félix Guattari, "Le capitalisme mondial intégré et la
révolution moléculaire" (lecture, Le Centre d'initiative
pour de nouveaux espaces de liberté, CINEL, 1981),
http://1libertaire.free.fr/Guattari4.html.

"dialectical image" through which the buried past of the vanquished "emerges suddenly, in a flash." Every great art-work, when it sets out in quest of the real, contains or harbors an anti-idealist device, including those that approach it through dreams or imagination, like the Surrealists, Jackson Pollock, Louise Bourgeois, or Mike Kelley. But what can the "real" of a world globalized by images and commodities look like? How can we wake up? The specificity of the twenty-first century is that though it produces forms, signs, and images industrially, most of its factories are located in the homes of individuals unaware they are working, irrigating the network daily with images and "personal data." The *product* bases its power on the deletion of every other class of object.

Among the movements that have emerged over the past few years, what is known as post-internet art sees networks as a new production framework, an economic and social matrix whose standards modify behaviors and representations. Constantly circulating between the real and the virtual, the material and the immaterial, these practices aim to display a new order of materiality, in which onscreen and real life take on each other's characteristics, and digital formats change our ways of feeling and exchanging. But while post-internet art calls into question the opposition between "online" and "offline," most of the artists affiliated with the movement (with the exception of Hito Steyerl, Timur Si-Qin, or Artie Vierkant) never venture into what lies beyond consumer society, even though the forms they manipulate obviously arise from it. If post-internet art has failed to generate a genuinely subversive mode of thinking, it is also because the generalization of the digital is no longer a critical urgency today: many artists had already integrated networks and pixels in a critical mode as early as the 1990s. Therefore, problematizing the digital era in binary terms (absence/presence, material/immaterial) isn't sufficient to create disruption. However, as a constellation of artists identified by the media, post-internet art proves that the succession of artistic movements of the twentieth century has induced some kind of Pavlovian reflex, which consists in hinging new ways of thinking on the appearance of new technology impacting the production or circulation of images. The model of *economic growth* has eased into the still-warm place of *progress*.

Other slower, less visible events have been re-configuring contemporary thinking much more deeply. The critique of the divide between nature and culture is foremost among these. This awareness has led artists to seek out the *real*, that is, what can durably resist the dere-alization organized by the dominant ideology. This ideology is founded on the notion of *mass*: mass production and consumption provide the structural basis of the globalized economy, from industries relocated to low-wage countries, to algorithms collecting the "personal data" of users. The internet is an instrument of massification, the chief locus of algorithmic "biopower," but this fundamental subject has remained unexamined by post-internet practices caught in the dialectics of pixel versus matter. If contemporary prac-tices are indeed crossing a crucial turning point, it is in as-serting themselves as "post-cultural," in the sense that they have discarded another series of binary oppositions (pop culture versus high culture) in order to explore the absolute singularity of physical realities. Composing ecosystems in which alloys prevail over the *given*, these works no longer display themselves as *masses* (molar) but as molecular compositions, artistic *polymers*.

The fact that the works of Daiga Grantina, Alisa Baremboym, Jared Madere, Marlie Mul, and Juliette Bonne-viot focus on part-synthetic, part-organic composite ma-terials, points to a sort of fusion between the properties of form and material. The visible outcome of their work seems to result from a chemical alloy (or assemblage), as though elaborating a sculpture or an installation followed the same rules as composing a living organism. This is what Alice Channer calls "figurative but without a body."[36] The point is to "[return] the human to the realm of the natural behavior of animals, materials, and systems," as Timur Si-Qin said, showing "how the properties and capacities of materials shape us, our cultures, our languages, and our econo-mies."[37] Whether through extraction or injection,

[36] Alice Channer, interview by Rosanna McLaughlin, *Studio International*, August 11, 2016, https://studiointernational.com/index.php/alice-channer-interview-early-man-burial-rockfall.

[37] Timur Si-Qin, in conversation with Katja Novitskova, *Living Content*, November 9, 2017, https://www.livingcontent.online/interviews/katja-novitskova-and-in-conversation-timur-si-qin.

the fusion of heterogeneous materials or analytical decom-
position, these artists question human societies via the
physicochemical assemblies that make up both their frame-
works and their tools. We could argue that these *reduction*
processes, these translations of the world into particles and
atoms, is equivalent to the way capitalism operates when
it reduces beings and things to another type of unit: mon-
etary value. On the contrary, molecular artistic practices
aim to intensify reality by valorizing the unique composition
of each fact or phenomenon. While neoliberal logic turns
the world into a commercial abstraction, art pursues the
opposite objective by giving even the tiniest particle a con-
crete, singular value. It is from this viewpoint that we can
understand the aims of Pierre Huyghe and Mark Leckey: "to
intensify the presence of what is" for the former, or "to em-
pathize with things" for the latter.

 Joseph Beuys revitalized Aristotle's hylomorphic
(matter/form) principle by extending it to all human activity,
defining sculpture as "the trace of action on matter." But
the new generation of artists is characterized by a common
mode of composition that opposes this principle. Instead
of imprinting gestures or thoughts on supposedly blank or
neutral materials, they use active elements, set out on a
single plane. There is no more background to trace forms
on: all is form. A universe of particles of equal status, to be
later *specified* by the meaning they take on in social life,
replaces the supports and surfaces of Western aesthetics.
Thus, seemingly similar molecular forms can refer to cultur-
al hierarchies or to the construction of the individual with
Philip Zach, to the world of technology with David Douard
or Daiga Grantina, or to transhumanism with Jeanne Briand
or Ivana Basic. Refusing to impose a form on an allegedly
raw material, all of these artists proceed by putting into
contact various aspects of the living, connecting processes
and materials with no predetermined hierarchy whatso-
ever: a speck of dust will be considered as intently as a
consumer good, and the parasites of communication are
put at the same level as its content. To reduce to the es-
sential, they seldom cross the threshold leading to visible
form, remaining at the "proto-stage" of the molecular: Dora
Budor's fake ash blowers, the cat pheromones diffused
within Pamela Rosenkranz's exhibition space, Sam Lewitt's
particles stirred by ventilation systems (or the fuel ashes
he manipulates), the electrical current or solar energy cir-

culating in Johannes Büttner's installations are all plastic elements, despite being invisible to the naked eye. Theirs is an aesthetics of redistribution—the artist's action on the states of matter is as important as our gaze on the social status of objects. Art becomes a kind of atomic transformer. The visible is no more than one of its many potential *effects*. The molecular level of reality can thus be perceived as the space of the Real, upstream from the reattributions established by the system, the labels through which we are meant to understand our milieu.

Hence the ubiquity of certain gestures: pulverization and decomposition, lysis and analysis; piles of matter, chemically decomposing objects, invisible particles, micro-organisms. Loris Gréaud incinerated all his artist's proofs in a crematorium, along with the brass plates, allowing him to collect the energy of this combustion for later works. Representations themselves can be atomized by technology: the works of Artie Vierkant or Ian Cheng no longer aim to represent the world, but to find the points through which it manifests itself and operates, the source from which it draws its morphological power; in other words, the capacity of the world to generate forms and to produce effects. For Katja Novitskova, "The key word in any contemporary materialist philosophy (and I think the kind of animism to which I relate is a materialist animism) is morphogenesis—the birth of form. Whether it is the birth of the form of mountains, clouds, plants, animals, flames—everything has form, interesting forms, driven by self-organizing properties of matter."[38] And in this play on forms, the artist is above all a translator. Loris Gréaud says of his work that it consists in "translating a waveform into sculpture, a light phenomenon into a rumor, cerebral energy into vibratory impulses."[39] Art is the *power of translation*, examining and redistributing forms of continuity and discontinuity that exist between humans and nonhumans.

In this play on molecularization, the human figure no longer exists, except through connections, as though it were being dissolved in a *solution* (in the chemical sense of the term). Human anatomy is shown as an assemblage of

[38] Katja Novitskova, " Techno-animism," *Mousse*, no. 37, February–March 2013.

[39] Loris Gréaud, in Nicolas Bourriaud, "L'artiste comme administrateur système," *L'officiel art*, 2014.

organs onto which prosthetics are plugged. For Alisa Bar-emboym, "There is no longer a line between organic composition and appendage [...] the appendages exist somewhere between hardware and software, fully integrated and functioning along with us."[40] If anthropoid forms have become ubiquitous in the art of today, they are extended to the vegetal or machinic, like Douard's network bodies, in which human saliva functions as a conduit for exchanges between bodies, words, and products. The human body is generally represented as a *locus* traversed by forces, rather than as an autonomous instance. Art shows bacteria and microbes, parasites and hormones, like messenger angels in Renaissance painting, as points of contact between worlds, factors of metamorphoses: they are the privileged agents of a recomposition of the visible. Max Hooper Schneider, who formerly studied biology, conceives his artistic practice in terms of "vibrational intercourse" with the surrounding milieu. Is the work of art a container or a recipient, or rather a source of emissions? "Even something that is vacuum-sealed will leak," he explains. "There is no closed system; nothing is impervious to molecular highways." Often structured like vivariums, his pieces are neither autonomous nor static. Instead, they arise from their porosity: "As they age, they will accumulate dust, form algae, generate coral polyps, chromatically shift. I chose to view my works in terms of the Ancient Greek market, the 'agora'—i.e., as an assembly point or a gathering place for all types of exchange."[41]

In *The Life of Plants*, Emanuel Coccia puts forward a "metaphysics of mixture" where the image is stripped of its function as representation in favor of its value as a "germ," its capacity to generate effects in time: "To be in the world necessarily means to *make world*: every activity of living beings is an act of design upon the living flesh of the world."[42] Another philosopher, Frédéric Neyrat, thinks along the same lines when he sees in contemporary art "images that lose their status as images—as imago, imprint—to immediately turn into technical tools."[43] By including the living in all its forms, these *inclusive* works emphasize *method* (etymologically: a path, a road, a way, or manner) rather than its visual results. One of the modes of visibility of the molecular level of reality, in other words, the moments when it is most likely to appear, is when it turns into energy: Büttner, Gréaud, and Lewitt thus compose

formal circuits aiming to include forces within forms, to produce energetic designs, including all the transformation processes of matter. The point is to display the way forms *circulate* rather than to present them in their static state; thus, artworks take on the aspect of *journey-forms*, moving beyond the boundaries of the exhibition space to spread out and irradiate their environment. Though the artwork is still "located" within its context, as were many Conceptual art pieces in the 1960s or the monumental interventions of Land art, their context is no longer an institution or a landscape, but the cosmos, the planet Earth as a physical reality and a space of interaction. Today, the in situ concerns the chain of the living and our molecular milieu in particular.

In this new formal universe, the object is pulverized or disseminated, while the human body, rather than being summed up by the notion of "cultural identity" as it was in the age of postmodernism, becomes a shunting yard traversed by geology, IT, or chemistry. In 1966, acknowledging the crisis of the human sciences, Michel Foucault wrote: "It is no longer possible to think in our day other than in the void left by man's disappearance. For this void does not create a deficiency; it does not constitute a lacuna that must be filled. It is nothing more, and nothing less, than the unfolding of a space in which it is once more possible to think."[44] At the time, Foucault envisioned a recomposition of thought around new objects by moving away from anthropocentrism. Today, the question raised by the "death

[40] Alisa Baremboym, quoted in Ruba Katrib, "Hyper-Materiality," *Kaleidoscope*, no. 18, Summer 2013, http://kaleidoscope-press.com/issue-contents/hypermaterialityinterview-by-ruba-katrib/.

[41] Max Hooper Schneider, interview by Henri Neuendorf, *Artnet*, December 12, 2017, https://news.artnet.com/art-world/max-hooper-schneider-interview-1121579.

[42] Coccia, *Life of Plants*, 39.

[43] Frédéric Neyrat, *Homo Labyrinthus: Humanisme, antihumanisme, posthumanisme* (Paris: Éditions Dehors, 2015), 128.

[44] Michel Foucault, *The Order of Things* (London: Tavistock Publications, 1970), 373.

of Man" takes on an entirely new meaning. The major *de-centering* we are experiencing in the Anthropocene, with its looming threat of ecological disaster, is ushering in an era in which art can find its place as a *solution*, as a transformative agent for our milieux: our mana.

Coda

Art is neither a profession among others, nor is it a catego-
ry of objects: it is both a substance and a space—mental,
social, and symbolic. This space is occupied by a force that
has had a thousand names throughout the ages, called
mana by the Melanesians. It is the locus where reality puts
in place its carnivalesque inversion, its critical questioning;
where social life can be decomposed and reinvented.
What we find there today are intriguing things, works of art,
made by other human beings: they show our connection
with the living, reflecting the global promiscuity generated
by human activities today—whose sum we have called the
Capitalocene. These artworks bear witness to our mental
representations, our behaviors, our modes of thinking,
in what amounts to a feral anthropology of our times.
But they also act as *batteries,* energy generators, that not
only connect their beholders with the past of humanity but
extend to the present for future beholders.

 To quote the art historian George Kubler:
"Actuality is when the lighthouse is dark between flashes:
it is the instant between the ticks of the watch: it is a void
interval slipping forever through time. [...] Yet the instant of
actuality is all we ever can know directly. The rest of time
emerges only in signals relayed to us at this instant by innu-
merable stages and by unexpected bearers. These signals
are like kinetic energy stored until the moment of notice."[1]
These "relays" condense and refine the moment that saw
them emerge, generating in turn effects on our own time.
The history of art is the history of a *semiosis,* that is, in
Eduardo Kohn's words, "the name for this living sign pro-
cess through which one thought gives rise to another,
which in turn gives rise to another, and so on, into the po-
tential future."[2] In this, just like the Amazon forest, art is a
milieu that hosts multiple ecosystems, a giant memory of
affects and ideas. If we extrapolate a little, we could define
art as our main parasite. Who knows if the human species
has not developed, over time, a disposition for Beauty, an
interest in the production and the reception of visual forms

[1] George Kubler, *The Shape of Time: Remarks on
the History of Things*
(New Haven, CT: Yale University Press, 1962), 15.

[2] Eduardo Kohn, *How Forests Think: Toward an
Anthropology beyond the Human*
(Berkeley: University of California Press, 2013), 33.

in order to conserve and study a class of objects that bear witness to its evolution, while forming in the midst of societies a space where they can recompose? Who knows if art has not perpetuated itself among humans as a salutary bacterium whose true functions are not what we spontaneously ascribe to it? Speculation is science fiction.

Today, the ecological catastrophe and the pandemic crisis are inciting artists to meditate on their role and their work principles, both of which will necessarily induce new models for society. Is this the end of the spectacular production that marked the past twenty years? Are we witnessing a rising awareness of the potential of art as an instrument for sustainable development? Is art exiting, at last, the gray area at the margins of real economy where global capitalism has confined it? By pointing out the existing imbalance between subsistence practices and overpaid jobs, daily life and labor-value, exchange and commerce, artists bring to light counter-models: they open up the way to a new hierarchy of the *useful*, embracing cooperation between humans and nonhumans.

Like Roger Caillois's butterfly, but a butterfly that projects its patterns onto all available media, the artist creates a specific wavelength—that's how we recognize him or her, rather than by his or her way of doing things. This emission will be more or less intense, the power of its relays will be more or less efficient, but it will always form an energetic model, inherent to all production of signs.

Two aesthetic projects recurred throughout this book: "intensifying the presence of what is" (Huyghe) and "empathizing with things" (Leckey). These formulas have taken on an ironic twist in the age of COVID-19, with its attendant protocols for *reducing presence* within the human space. Working from home, tele-production, and online sales, the event of a planet-wide house arrest, the generalization of online meetings: all form the outlines of the civilization where tomorrow human relations could become marginalized, even criminalized, just like the meetings of so-called witches in the Middle Ages. Are we headed toward the "friction-free space" envisioned by Bill Gates? Toward a domesticated democracy, miniaturized to the size of home?

Since the 1990s, artists have given shapes to
(or occupied) the relational sphere, taking interhuman
relations, conviviality or conflicts, communities or neigh-
borhood utopias as a field of reference or as a material.
The current critical success of speculative realism in the
field of art seems to be the signal of another acceleration:
the evacuation process of the human. Relational art was
critiqued for its anthropocentrism, or even its "humanism"
in disguise; today, what seems untenable or outdated to
some is considering the human as an aesthetic and political
horizon, or even extending its domain by interacting with
objects, networks, nature, or machines. On the contrary, it
seems to me that the major political challenge of the twen-
ty-first century will consist, precisely, in *putting the human
back* everywhere it has been removed and replaced with
automation: into computational finance, into markets driven
by mechanical regulations, but above all into politics, now
fixated on the sole horizon of profit, that is, the world of the
quantifiable. Not at *its center,* since nothing can constitute
the center of a universe of beings in coactivity within a
shared ecosystem, but *at the heart* of those activities that
are human in name only today. Here, the molecular takes on
what Marx called the *automaton,* within the framework of a
broadened relational aesthetics.